COOL
PARIS

teNeues

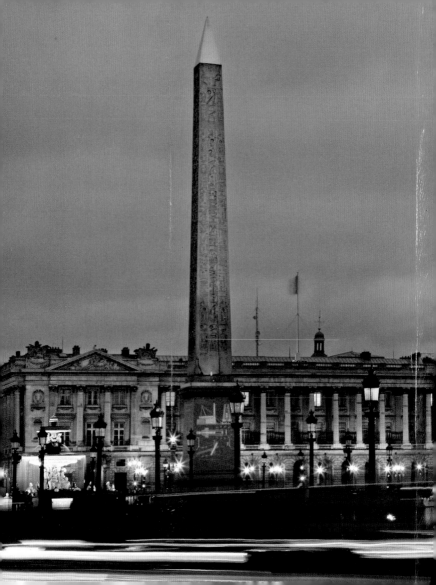

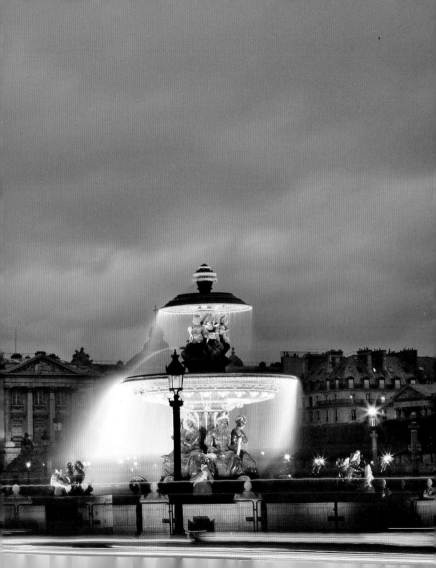

PRICE CATEGORY

$ = BUDGET $$ = AFFORDABLE $$$ = MODERATE $$$$ = LUXURY

COOL
CONTENT

INTRO

PARIS LIVES. ASIDE FROM BEING THE CITY OF LIGHT—WITH ITS GILDED AND MOLDED BUILDINGS GROUPED AT THE FOOT OF THE EIFFEL TOWER—IT ALSO HAS LIFE. THIS BEAUTIFUL FRAME CAN ONLY SERVE TO MAKE LIFE MORE VIBRANT: IT ALLOWS PEOPLE TO DRAW INSPIRATION, TO FANTASIZE. IT IS WITHIN THESE WALLS THAT PARIS TRULY EXISTS, AND IN WHICH IT UNVEILS ITS MOST MAGNIFICENT SPLENDORS. IT WAS IN THIS HISTORIC CAFÉ THAT THOSE WHOSE WORKS ARE NOW TAUGHT IN THE UNIVERSITIES ACROSS THE WORLD USED TO SIT. IT IS IN THAT RESTAURANT OVER THERE THAT THERE IS A CHEF STRIVING TO TANTALIZE THE TASTE BUDS. IT IS ON THE STANDS OF THIS INNOVATIVE BOUTIQUE THAT YOU BELIEVE THE HANGER IS AS EXPENSIVE AS THE ITEM OF CLOTHING HANGING FROM IT. IT IS IN THE BATHTUB OF THIS HOTEL ROOM WHERE YOU SAY TO YOURSELF, AT THE HEIGHT OF JOY: "THIS REALLY IS PARIS."

PARIS LEBT. DIE STADT DER LICHTER, IN DER SICH VERGOLDUNGEN UND VERZIERUNGEN AM FUSSE DES EIFFELTURMS DRÄNGEN, STRAHLT LEBENDIGKEIT AUS. IN EINEM SOLCH BEZAUBERNDEN SCHMUCKKÄSTCHEN WIE PARIS PULSIERT DAS LEBEN AUF BESONDERE ART UND WEISE – JEDE INSPIRATION, JEDE VISION IST WILL-KOMMEN. DIE STADT DER KÜNSTE MIT IHRER LEBENDIGEN VERGANGENHEIT HAT ABER AUCH DIE ZUKUNFT FEST IM BLICK. IN SEINEN GEBÄUDEN EXISTIERT PARIS WIRKLICH UND PRÄSENTIERT UNS SEINE SCHÖNSTEN SEITEN. IN DEM HISTORISCHEN CAFÉ, IN DEM SEINERZEIT DIE SASSEN, ÜBER DIE HEUTE AN DEN UNIVERSITÄTEN WELTWEIT GELEHRT WIRD. IN DEM RESTAURANT, IN DEM DER KREATIVE KÜCHENCHEF WAHRE GAUMENFREUDEN ZAUBERT. IN DEN AUSLAGEN DER INNOVATIVEN BOU-TIQUE, IN DER DIE KLEIDERBÜGEL GE-NAUSO WERTGESCHÄTZT WERDEN WIE DIE KLEIDUNGSSTÜCKE SELBST. IN DER BADEWANNE DES HOTELZIMMERS, IN DER MAN VOLLER FREUDE FESTSTELLT: „DAS IST DAS WAHRE PARIS."

PARIS VIT. AU DELÀ DE LA CAPITALE
DE LUMIÈRE, OÙ DORURES ET MODÉ-
NATURES S'ACCUMULENT AUX PIEDS
DE LA TOUR EIFFEL, IL Y A LA VIE. ET
DANS UN SI JOLI ÉCRIN, LA VIE EST
QUE PLUS VIBRANTE : ELLE PERMET
TOUTES LES INSPIRATIONS, TOUTES
LES FANTAISIES. C'EST UNE VILLE
D'ART, QUI VIT AVEC LE PASSÉ, MAIS
REGARDE TOUJOURS VERS L'AVE-
NIR. C'EST DANS SES MURS QU'ELLE
EXISTE VRAIMENT, QU'ELLE DÉVOILE
SES PLUS BEAUX ATOURS : DANS TEL
CAFÉ HISTORIQUE OÙ S'ASSEYAIENT
JADIS CEUX QUE L'ON ENSEIGNE
AUJOURD'HUI DANS LES UNIVERSITÉS
DU MONDE ; DANS TEL RESTAURANT
OÙ UN CHEF INSPIRÉ CONTINUE DE
FAIRE RÊVER LES PAPILLES ; SUR LES
ÉTALS DE TELLE BOUTIQUE INNO-
VANTE, QUI PENSE QUE LE CINTRE
VAUT AUTANT QUE LE VÊTEMENT.
OU DANS LA BAIGNOIRE DE TELLE
CHAMBRE D'HÔTEL, OÙ L'ON SE DIT,
AU SOMMET DE LA JOUISSANCE :
« ÇA C'EST VRAIMENT PARIS. »

PARÍS ESTÁ VIVO. MÁS ALLÁ DE LA
LUMINOSIDAD DE LA CAPITAL Y DE
LOS DORADOS Y MOLDURAS QUE SE
ACUMULAN A PIES DE LA TORRE EIFFEL,
LA CIUDAD BULLE DE VIDA. Y ESA VIDA,
EN UN MARCO TAN HERMOSO, NO
PUEDE SER SINO MÁS VIBRANTE, UN
ALGO INDESCRIPTIBLE QUE HACE
POSIBLES TODAS LAS INSPIRACIONES Y
FANTASÍAS. UNA CIUDAD APASIONADA
POR EL ARTE, QUE CONVIVE CON EL
PASADO MIRANDO SIEMPRE HACIA EL
FUTURO. EL VERDADERO PARÍS EXISTE
DE PUERTAS A DENTRO, ALLÍ ES DONDE
DESPLIEGA SUS MEJORES GALAS: EN EL
CAFÉ HISTÓRICO FRECUENTADO EN
OTRA ÉPOCA POR PERSONAS CUYA
OBRA SE ESTUDIA HOY EN LAS UNIVER-
SIDADES DE TODO EL MUNDO; EN UN
RESTAURANTE DONDE LA INSPIRACIÓN
DEL CHEF HACE LAS DELICIAS DE MIL
PALADARES; EN LAS DEPENDENCIAS
DE UNA TIENDA INNOVADORA EN LA
QUE PIENSAN QUE LA PERCHA ES TAN
IMPORTANTE COMO LA PRENDA; Y
TAMBIÉN EN LA BAÑERA DE UNA HA-
BITACIÓN DE HOTEL EN LA QUE UNO,
EBRIO DE GOZO, PUEDE DECIRSE A SÍ
MISMO: "ESTO, ESTO ES PARÍS."

HOTELS

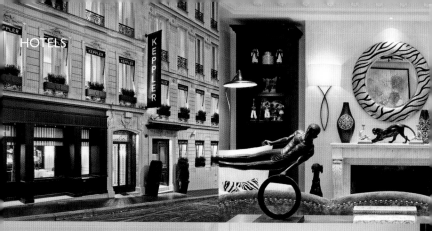

HÔTEL KEPPLER

10, rue Kepler // Champs-Élysées
Tel.: +33 (01) 47 20 65 05
www.keppler.fr

Métro Georges V
RER Charles de Gaulle / Étoile

Prices: $$$$

A stone's throw away from the Champs-Élysées, this hotel has, in only a few years, managed to become one of the jewels in the crown of the Parisian hotel scene. Its singular elegance, as conceived by the interior designer Pierre-Yves Rochon, offers a luxurious and delightful alternative to hotels in the Golden Triangle. The bar is something not to be missed, bringing together all the qualities of a domestic living room, at once warm and on-trend, combining the feel of a library, fireplace and glass panelling with views out onto the fabulous garden.

Nur wenige Schritte von den Champs-Élysées entfernt ist dieses Hotel innerhalb weniger Jahre zu einer der Perlen der Pariser Hotelszene aufgestiegen. Die einzigartige Eleganz, die dem Innenarchitekten Pierre-Yves Rochon zu verdanken ist, bietet eine luxuriöse und erfrischende Alternative zu den Hotels im Goldenen Dreieck. Verpassen sollte man auch nicht die Hotelbar, die sowohl gemütlich als auch trendy ist, die Qualitäten eines heimischen Wohnzimmers mit dem Ambiente einer Bibliothek verbindet und mit einem Kamin und einer Glaswand besticht, die den Blick in den wundervollen Garten schweifen lässt.

À deux pas des Champs-Élysées, cet hôtel a su s'imposer en quelques années comme l'un des joyaux de l'hôtellerie parisienne. Son élégance singulière, conçue par le décorateur Pierre-Yves Rochon, offre une alternative luxueuse et réjouissante aux hôtels du triangle d'or. Le bar, incontournable, réunit les qualités d'un salon de maison à la fois chaleureux et branché, mêlant des ambiances de bibliothèque, de coin du feu et de véranda ouvrant sur un fabuleux jardin.

Situado a dos pasos de los Champs-Élysées, el establecimiento ha sabido imponerse en pocos años como una de las joyas de la hotelería parisina. Su elegancia singular, mérito del decorador Pierre-Yves Rochon, ofrece una alternativa lujosa y gratificante a los hoteles del triángulo de oro. El bar, de visita obligada, resulta a un tiempo acogedor y moderno, por cuanto en él se combinan el acogedor ambiente del hogar, con su biblioteca, su rincón frente a la chimenea y unas puertas vidriadas que se abren a un extraordinario jardín.

HÔTEL
LE BRISTOL
PARIS

112, rue du Faubourg-Saint-Honoré
Champs-Élysées
Tel.: +33 (01) 53 43 43 00
www.lebristolparis.com

Métro Miromesnil or
Saint-Philippe-du-Roule

Prices: $$$$

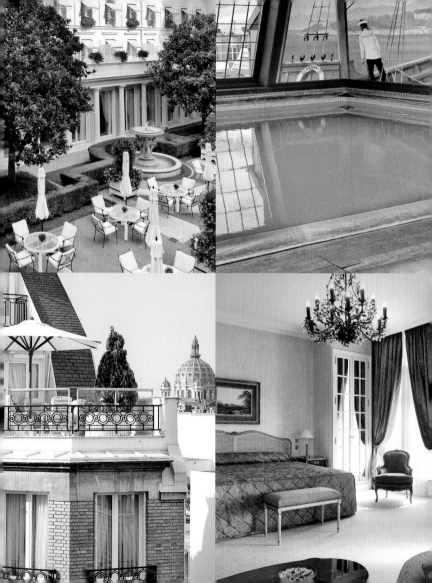

Hôtel Le Bristol, a true Parisian monument, could be said to have watched this city growing up. Set up in 1925 in a private residence, and a temple to 18th century Parisian high life, this establishment has housed the greatest names of international celebrity: Josephine Baker, Konrad Adenauer, Charlie Chaplin and even Mick Jagger. Its first exhibition, dedicated to the artist Diane von Württemberg, was organized in 2007 in the immense gardens of the Bristol.

Das Hôtel Le Bristol gehört zu den Denkmälern der Stadt und kann als Zeuge der Entwicklung der Stadt bezeichnet werden. Es wurde 1925 in einem privaten Anwesen erbaut. Als Tempel des gesellschaftlichen Lebens des 18. Jahrhunderts hat dieses Gebäude schon internationale Größen wie Josephine Baker, Konrad Adenauer, Charlie Chaplin und sogar Mick Jagger beherbergt. Seine erste Ausstellung hat das Haus 2007 in den großzügigen Gärten des Bristol der Künstlerin Diane von Württemberg gewidmet.

BRUNO FRISONI'S SPECIAL TIP

For a great stay, this is one of the best hotels in the world, and the only one that has a cat as a permanent guest!

Le Bristol, véritable monument parisien, a vu la ville se développer. Installé en 1925 dans un hôtel particulier, temple de la vie mondaine parisienne du XVIIIe siècle, l'établissement a hébergé les plus grands noms de la scène internationale : Josephine Baker, Konrad Adenauer, Charlie Chaplin ou encore Mick Jagger. Une première exposition, dédiée à l'artiste Diane von Württemberg, a été organisée dans les immenses jardins du Bristol en 2007.

El Bristol, auténtico monumento parisino, ha sido testigo constante del devenir de la ciudad. Inaugurado en 1925 en una antigua residencia particular, lugar de encuentro frecuente de la sociedad parisina en el siglo XVIII, el establecimiento ha acogido entre sus muros a las más importantes figuras de los escenarios mundiales: Josephine Baker, Konrad Adenauer, Charlie Chaplin e incluso Mick Jagger. En 2007 se organizó en los inmensos jardines del Bristol la primera exposición de arte, dedicada a Diane von Württemberg.

HOTELS

LITTLE PALACE HOTEL

4, rue Salomon de Caus
Le Marais
Tel.: +33 (01) 42 73 08 15
www.palace-paris-hotel.com

Métro Réaumur / Sébastopol

Prices: $$$

The classical contemporary elegance à la française of the Little Palace Hotel can be seen straight away from its façade, dating from the beginning of the 20th century. The last word in comfort, the premises are situated just a few minutes from cultural hot-spots of Paris that are not to be missed, such as the Marais, the Pompidou Centre, Notre-Dame, the Louvre Museum, and many more. The ultimate luxury: a private garden is situated just beneath the windows of its sculpted stone façade.

Die klassische zeitgenössische Eleganz à la française des Little Palace Hotels ist bereits an der Fassade aus dem frühen 20. Jahrhundert zu erkennen. Nur wenige Minuten entfernt von kulturellen Hotspots wie dem Marais, dem Centre Pompidou, Notre-Dame, dem Louvre-Museum und anderen Highlights werden hier höchste Komfortbedürfnisse gestillt. Das luxuriöse Highlight des Hotels ist der private Garten direkt unter den Fenstern der steinernen Fassade.

L'élégance à la française d'un classicisme contemporain se devine déjà sur sa façade début de XXe siècle. Pour un confort maximal, l'établissement est à quelques minutes seulement des incontournables lieux culturels parisiens, comme le Marais et le centre Pompidou, Notre-Dame, le Musée du Louvre… Luxe ultime : un jardin privatif sous les fenêtres de la façade depierres sculptées.

El clasicismo contemporáneo de la elegancia francesa se adivina ya en su fachada de comienzos del siglo XX. El establecimiento goza de una óptima ubicación, a escasos minutos de los principales espacios culturales de la capital como Le Marais y el Centro Pompidou, Notre-Dame, el museo del Louvre, cuenta también con todo un lujo: un jardín privado bajo las ventanas de la fachada de piedra tallada.

 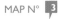

HÔTEL
LUMEN PARIS

15, rue des Pyramides // Louvre
Tel.: +33 (01) 44 50 77 00
www.hotel-lumenparis.com

Métro Pyramides

Prices: $$

With its cameos in grey and its play of light, Hôtel Lumen
has managed to bridge the centuries with the greatest of ease.
Its neo-baroque decoration is unique, born out of the imagi-
nation of Herman Bal, manager and owner, and his aides, the
designers Claudio Colucci and Giuseppe Chierchia. His work,
centred on calm and light, adds to the perfect sense of place-
ment that the hotel has in the art and history quarter, where
the Palais Royal, Opéra and Louvre Museum all rub shoulders.

Mit seinen grauen Kameen und dem Spiel mit dem Licht hat
es das Hôtel Lumen geschafft, die Jahrhunderte auf einfachste
Art zu vereinen. Die neobarocke Einrichtung ist ein Unikat,
das durch die Fantasie von Herman Bal, dem Manager und
Besitzer des Hauses, und die Unterstützung der Designer
Claudio Colucci und Giuseppe Chierchia entstanden ist. Im
Mittelpunkt seiner Arbeit stehen Ruhe und Licht. Diese Wahl
passt hervorragend zur Lage des Hotels in einem Viertel, das
sich Kunst und Geschichte verschrieben hat. Unmittelbare
Nachbarn sind das Palais Royal, die Oper und der Louvre.

Avec ses camaïeux de gris et ses effets de lumière,
l'Hôtel Lumen s'adapte à son environnement et à son
temps tout en douceur. La décoration néo-baroque
et insolite de cet hôtel est née de l'imagination de son
directeur et propriétaire, Herman Bal, épaulé des de-
signers Claudio Colucci et Giuseppe Chierchia. Ce travail
sur le calme et la lumière contribue à la parfaite implan-
tation de cet hôtel dans un quartier d'art et d'histoire,
où se côtoient le Palais Royal, l'Opéra et le Louvre.

Con sus claroscuros en gris y sus efectos de luz, el Hôtel
Lumen se engarza sin fisuras en su entorno y su tiempo.
La insólita decoración neobarroca del hotel es fruto de
la imaginación de su director y propietario, Herman Bal,
asistido por los diseñadores Claudio Colucci y Giuseppe
Chierchia. La calma y la luminosidad que de él emanan
contribuyen a la perfecta integración del hotel en un
barrio rico en arte e historia en el que convive con el
Palais Royal, la Ópera y el Louvre.

HÔTEL AMOUR

8, rue de Navarin // Pigalle
Tel.: +33 (01) 48 78 31 80
www.hotelamourparis.fr

Métro Saint-Georges

Prices: $$

This establishment wears its name well: indeed, love was formerly for sale in this old hotel in the Montmartre district. Its heritage still bears influence on the current policies of this hotel which allows rooms to be rented by the hour. The fittings and decorations just manage to provide a brief glimpse into its devilish past, on the way from the retro bistro to the bedrooms you will find melting-pots signed by artists such as Sophie Calle or Pierre Le Tan, looking over a green courtyard.

Das Hotel trägt seinen Namen zu Recht, denn früher wurde in dem ehemaligen Freudenhaus auf dem Montmartre-Hügel Liebe verkauft. Dieses Erbe schlägt sich noch heute in der Politik des Hotels nieder: Die Zimmer werden auch stundenweise vermietet. Bistro im Retro-Stil, bunt gemischte, von Sophie Calle und Pierre Le Tan entworfene Zimmer, ein begrünter Innenhof – Einrichtung und Gestaltung lassen die verruchte Vergangenheit kaum noch erahnen.

L'établissement porte bien son nom : en effet, c'est de l'amour que l'on vendait jadis dans cet ancien hôtel de passe de la butte Montmartre. Un héritage maintenu jusque dans la politique de l'hôtel qui permet de louer des chambres à l'heure. L'aménagement et la décoration laissent à peine entrevoir ce passé sulfureux, entre bistro rétro et chambres melting-pots signées Sophie Calle ou Pierre Le Tan, surplombant une cour végétale.

El nombre del establecimiento le viene que ni pintado: efectivamente, en este venerable hotel de paso sito en Montmartre el amor era mercancía de compra y venta, una herencia presente todavía en la política del hotel, que permite todavía alquilar las habitaciones por horas. El mobiliario y la decoración apenas reflejan este pasado tortuoso, ni en el restaurante retro ni en la abigarrada mezcla de estilos de las habitaciones diseñadas por Sophie Calle y Pierre Le Tan que se elevan sobre un patio ajardinado.

MAMA SHELTER

109, rue de Bagnolet
Porte de Bagnolet
Tel.: +33 (01) 43 48 48 48
www.mamashelter.com

Métro Gambetta or Porte de Bagnolet

Prices: $$

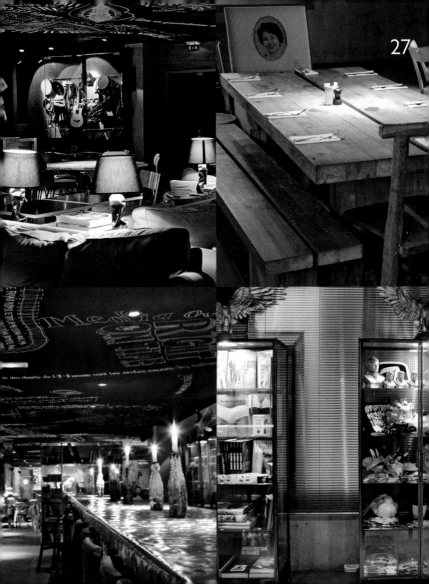

Mama Shelter was born out of a bet between a family, a philosopher and a designer. Its urban lines, designed by the architect Roland Castro, unite with a bric-a-brac interior artistically decorated by Philippe Starck. Mama's bars and restaurants are a treat for the eyes and taste buds of its eclectic clientele. Fitted with kitchenettes, these intimate and trendy rooms promise you complete freedom during your stay.

Das Mama Shelter verdankt sein Entstehen einer ebenso verrückten wie lustigen Wette zwischen einer Familie, einem Philosophen und einem Designer. Die vom Architekten Roland Castro entworfenen urbanen Linien treffen auf ein künstlerisches Sammelsurium im Inneren, für das Philippe Starck verantwortlich zeichnet. Ein wahrer Schmaus für Augen und Gaumen des breit gefächerten Publikums sind die Bars und Restaurants des Hauses. Jedes der gemüt-lichen Designzimmer verfügt über eine Kitchenette, die den Gästen während ihres Aufenthalts alle Freiheiten lässt.

BRUNO FRISONI'S SPECIAL TIP

A great place for brunch, with the kids or with a group of friends!

C'est d'un pari fun et fou entre une famille, un philosophe et un designer que le Mama Shelter a vu le jour. Ses lignes urbaines, dessinées par l'architecte Roland Castro, se conjuguent à un inté-rieur bric-à-brac artistement élaboré par Philippe Starck. Les bars et restaurants du Mama régalent les yeux et les papilles d'une clientèle éclectique. Équipées de kitchenettes, les chambres intimes et design promettent des séjours de pleine liberté.

La aparición de Mama Shelter tiene su origen en una disparatada apuesta entre una familia, un filósofo y un diseñador. Sus líneas urbanas, diseñadas por el arquitecto Roland Castro, combinan a la perfección con el heterogé-neo interior artísticamente elaborado por Philippe Starck. Los bares y restaurantes del Mama son un placer para la vista y el paladar de su ecléctica clientela. Las habitaciones, intimistas y de diseño, cuentan con cocina propia y son garantía de absoluta libertad durante la estancia.

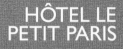

HÔTEL LE PETIT PARIS

214, rue Saint-Jacques
Quartier Latin
Tel.: +33 (01) 53 10 29 29
www.hotelpetitparis.com

Métro Luxembourg

Prices: $$

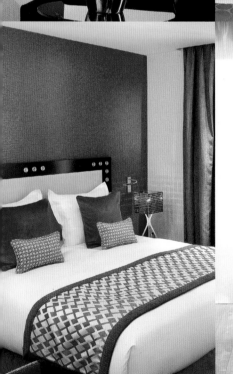

Set up beneath Paris' medieval city walls in an 18th century staging post, Le Petit Paris has been giving shelter to travelers and bohemian artists for more than a century. The rooms, decorated by interior designer Sybille de Margerie, offer a journey to the centre of all trends, from the Middle Ages to the Seventies. Such trends, combined in a knowing blend, also provide inspiration for the breakfast room, which opens out onto an airy patio.

Das an mittelalterlichen Gemäuern gelegene Le Petit Paris, das im 18. Jahrhundert als Postamt diente, empfängt seit mehr als hundert Jahren Reisende und Künstler der Bohème. Die von der gefeierten Innenarchitektin Sybille de Margerie entworfenen Zimmereinrichtungen nehmen den Gast mit auf eine Reise durch die Epochen, vom Mittelalter bis zu den Siebzigern. Im Frühstücksraum vereinen sich die verschiedenen Stile auf raffinierte Weise, der angrenzende Innenhof eignet sich zur Erfrischung.

Aménagé sous les remparts du Paris médiéval dans un relais de poste du XVIIIe siècle, le Petit Paris héberge voyageurs et artistes bohèmes depuis plus de cent ans. Les chambres, décorées par la star de l'architecture d'intérieur, Sybille de Margerie, proposent un voyage au cœur des tendances, du moyen-âge aux seventies. Tendances dont s'inspire la salle de petits déjeuners, pour un savant mélange de styles donnant sur un rafraîchissant patio.

Instalado tras las murallas del París medieval, en un relevo de postas del siglo XVIII, el Petit Paris lleva más de cien años acogiendo bajo su techo a viajeros y artistas bohemios. Las habitaciones, decoradas por la estrella del interiorismo Sybille de Margerie, proponen un viaje al corazón de las diversas tendencias, desde el Medievo hasta los años setenta. Las mismas tendencias inspiran la sala de desayuno cuya sabia combinación de estilos se abro a un refrescante patio.

HÔTEL GABRIEL
PARIS MARAIS

25, rue du Grand Prieuré
République
Tel.: +33 (01) 47 00 13 38
www.hotel-gabriel-paris.com

Métro Oberkampf or République

Prices: $$

Just like an island in the city, the Hôtel Gabriel is the first Parisian establishment to offer a programme based entirely around detox. From the design of the suites to the restaurant menu, everything has been conceived around the themes of well-being and relaxation. Some of the rooms come with a sleep-enhancing system, brain child of Professor Damien Léger and designer Patrick Jouin. Organic cosmetics are given pride of place in the bathrooms and massage parlours.

Im Stile einer Oase mitten in der Stadt bietet das Gabriel als erstes Hotel in Paris seinen Gästen ein ganz der Entgiftung des Körpers gewidmetes Programm. Von der Einrichtung der Zimmer bis zur Speisekarte im Restaurant – alles steht im Zeichen des Wohlbefindens und der Entspannung. Einige Zimmer verfügen über eine von Professor Damien Léger und dem Designer Patrick Jouin konzipierte spezielle Beleuchtung für einen besseren Schlaf. In den Badezimmern und Massageräumen können sich die Gäste von den Produkten der Marke „Bioo" verwöhnen lassen.

Comme une île en ville, l'hôtel Gabriel est le premier établissement parisien à proposer un programme entièrement dédié au détox. Du design des suites à la carte du restaurant, tout a été pensé autour du bien-être et de la relaxation. Certaines chambres sont équipées d'un accompagnateur de sommeil, fruit du travail du Professeur Damien Léger et du designer Patrick Jouin. Les cosmétiques « Bioo » sont à l'honneur dans les salles de bains et de massages.

Como si de una isla en pleno centro urbano se tratase, el hotel Gabriel es el primer establecimiento parisino en proponer un programa centrado por entero en la eliminación de toxinas. Desde el diseño de las habitaciones a la carta del restaurante, todo ha sido concebido con el bienestar y el relax en mente. Algunas habitaciones están dotadas de "máquinas del sueño", creadas por el profesor Damien Léger en colaboración con el diseñador Patrick Jouin. Los cosméticos "Bioo" ocupan un lugar de honor en cuartos de baños y salones de masaje.

MURANO RESORT

13, boulevard du Temple // République
Tel.: +33 (01) 42 71 20 00
www.muranoresort.com

Métro Filles du Calvaire

Prices: $$$$

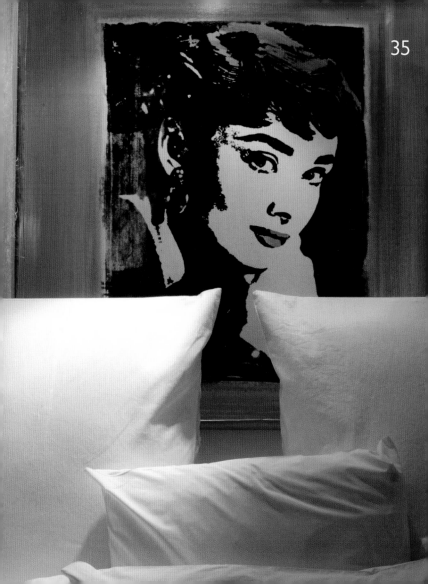

The Murano Resort belongs to the new generation of top class hotels, where luxury and a casual attitude go hand in hand. Its brightly coloured bar is the catwalk backdrop to its distinguished clientele, who are often used to frequenting such settings. The rooms and suites make a stay in this hotel go beyond the simple pleasure of contemporary decoration, and into an unforgettable sensory experience, where volumes seem to represent the needs of body and mind.

Das Murano Resort gehört zur neuen Generation der Hotels der Spitzenklasse, in denen Luxus und Lässigkeit Hand in Hand gehen. Die farbenprächtige Bar dient den illustren Gästen, die sich häufig in solchen Umgebungen bewegen, als Laufsteg. Die Zimmer und Suiten vermitteln dem Gast mehr als nur den einfachen Genuss von zeitgenössischem Ambiente. Der Besuch wird zu einem unvergesslichen Erlebnis für die Sinne, weil die Formen die Bedürfnisse von Körper und Geist auszudrücken scheinen.

Le Murano Resort s'inscrit dans la branche de ces palaces urbains nouvelle génération, où luxe rime avec décontraction. Son bar aux couleurs vives voit défiler une clientèle people adepte de lounge. Dans les chambres et suites, le séjour à l'hôtel dépasse la simple appréciation d'une décoration contemporaine et audacieuse et devient une expérience sensorielle inoubliable où les formes semblent répondre aux besoins du corps et de l'esprit.

El Murano Resort se inscribe en el modelo de palacios urbanos de nueva generación en los que el lujo y el relax van de la mano. Por su bar de vivos colores desfila una clientela ansiosa por ver y ser vista. En las habitaciones y suites, la estancia en el hotel va más allá de la simple contemplación de una decoración contemporánea y audaz para pasar a ser una inolvidable experiencia sensorial en la que las formas parecen haber sido concebidos a medida del cuerpo y el espíritu.

APOSTROPHE
HÔTEL

3, rue de Chevreuse
Saint-Germain-des-Prés
Tel.: +33 (01) 56 54 31 31
www.apostrophe-hotel.com

Métro Vavin

Prices: $$

While cozy, lounge-like atmospheres of Parisian hotels can often be at odds with the electric buzz of the city, Apostrophe stands out for its ultra urban interiors. Both inspired and inspiring, these premises refuse any form of uniformity. Indeed, each of its 16 rooms has its own atmosphere and its own history. For example, the Paris-Paradis suite offers visitors a panoramic view to take your breath away… all without opening the curtains.

Während sich einige Pariser Hotels durch ihre gemütliche Lounge-Atmosphäre von Trubel und Hektik der Stadt abgrenzen, setzt das Apostrophe auf ein ausgesprochen urbanes Design. Inspiriert und inspirierend zugleich, lehnt das Hotel jegliche Form der Gleichförmigkeit ab. Jedes der 16 Zimmer verfügt über ein individuelles Ambiente, eine eigene Geschichte. Die Suite Paris-Paradis beispielsweise bietet einen überwältigenden Panoramablick – bei geschlossenen Vorhängen.

Alors que les atmosphères cosy et lounge des hôtels parisiens tranchent avec l'ambiance électrique de la ville, l'Apostrophe se distingue par une décoration ultra-urbaine. Inspiré et inspirant, l'établissement refuse l'uniformité. En effet, chacune des 16 chambres possède sa propre ambiance, sa propre histoire. A titre d'exemple, la suite Paris-Paradis offre une vue panoramique époustouflante…à rideaux fermés.

Así como el ambiente pausado y casi casero de los hoteles parisienses tiende a contrastar con el ritmo frenético de la ciudad, el Apostrophe se distingue por una decoración ultraurbana. Inspirado e inspirador, el establecimiento ha declarado la guerra a la uniformidad, y cada una de sus 16 habitaciones posee un estilo y una historia propios. Valga como ejemplo la suite Paris-Paradis, que ofrece una asombrosa vista… de sus cortinas cerradas.

HÔTEL BEL AMI

7/11, rue Saint-Benoît
Saint-Germain-des-Prés
Tel.: +33 (01) 42 61 53 53
www.hotel-bel-ami.com

Métro Saint-Germain-des-Prés

Prices: $$$

Located in a former printing press in that most typical quartier of Paris, Hôtel Bel Ami is something of a house of aesthetics. Each suite, designed by the architect Pascal Allaman and the stylist Marina Bessé, demonstrates a refined harmony between color and material. Proud of its history and lineage, this polymorphous, polychrome hotel organizes concerts and exhibitions, and even gives out its own literary prize each year.

Im ursprünglichsten Pariser Viertel entstand aus einer ehemaligen Druckerei das Hôtel Bel Ami, in dem wahre Ästheten ganz auf ihre Kosten kommen. Der Architekt Pascal Allaman und die Designerin Marina Bessé schufen in Zusammenarbeit Suiten, deren Farben und Materialien aufs Wunderbarste harmonieren. Dieses Hotel, in dem die unterschiedlichsten Farben und Formen eingesetzt wurden, ist stolz auf seine Geschichte und seine Wurzeln. Hier finden Konzerte und Ausstellungen statt und jedes Jahr wird der hauseigene Literaturpreis vergeben.

Dans une ancienne imprimerie du quartier le plus typique de Paris, l'hôtel Bel Ami fait figure de maison d'esthète. Chaque suite, conçue par l'architecte Pascal Allaman en collaboration avec la styliste Marina Bessé, présente une harmonie raffinée de couleurs et de matières. Fier de son histoire et de son ancrage, cet hôtel polymorphe et polychrome organise concerts, expositions et décerne chaque année son propre prix littéraire.

Instalado en una antigua imprenta en el barrio más característico de París, el hotel Bel Ami da la impresión de ser una casa de estetas. Cada una de sus suites, diseñadas por el arquitecto Pascal Allaman junto con la diseñadora Marina Bessé, presenta una refinada armonía de colores y materiales. Orgulloso de su historia y su arraigo, el hotel, polimorfo y polícromo, organiza conciertos y exposiciones y concede cada año un premio literario propio.

L'HÔTEL

13, rue des Beaux-Arts
Saint-Germain-des-Prés
Tel.: +33 (01) 44 41 99 00
www.l-hotel.com

Métro Saint-Germain-des-Prés

Prices: $$$

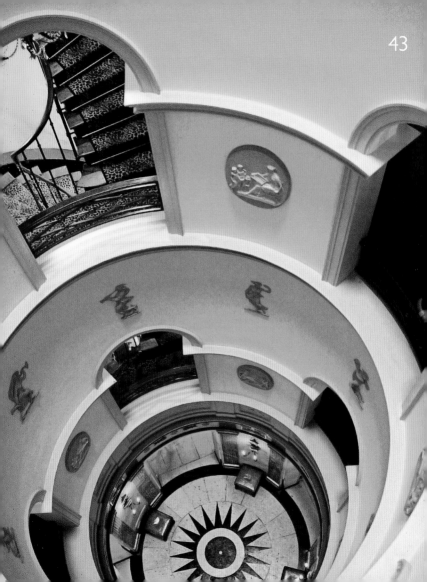

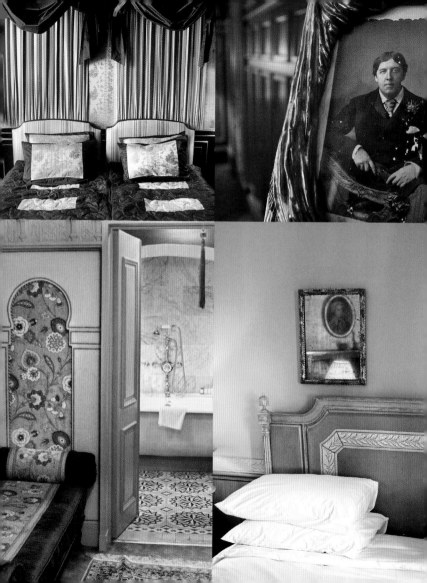

Right at the heart of the Saint-Germain art gallery quarter you will find this jewel of a hotel, with around twenty unique rooms available. Former lovers' haunt for Queen Margot and then a refuge for Oscar Wilde, l'Hôtel has had its neo-classical columns redecorated by the craftsman Alain Pouliquen—the same hand that decorated the Paris Opéra. The cellar vaults of the hotel are today home to roman thermal baths, with swimming pool and hammam.

Dieses Juwel liegt im Herzen des Galerienviertels von Saint-Germain – ein Hotel mit ungefähr zwanzig einzigartigen Zimmern. Im l'Hôtel, dem ehemaligen Liebesnest von Königin Margot und späteren Refugium von Oscar Wilde, wurden von Künstler Alain Pouliquen, der einst auch die Pariser Oper dekorierte, die neoklassischen Säulen neu vergoldet. Das Kellergewölbe dient heute als römische Therme mit Pool und Hammam.

BRUNO FRISONI'S SPECIAL TIP

Paris, Paris, wonderful neoclassical staircase, beautiful decor and great atmosphere, all right in front of Les Beaux Arts! If antiques are your thing, this is the place to be!

C'est au milieu des galeries d'art de Saint-Germain que se cache ce bijou d'une vingtaine de chambres, toutes bien spécifiques. Ancien repaire des amours de la reine Margot, puis refuge d'Oscar Wilde, l'Hôtel a vu ses colonnes néo-classiques redorées par la main de l'artisan Alain Pouliquen, décorateur de l'Opéra de Paris. Les voûtes des caves de l'hôtel accueillent aujourd'hui des thermes romains, avec piscine et hammam.

Oculto entre las galerías de arte de Saint-Germain se esconde una joyita de apenas veinte habitaciones, cada una distinta e individual. Antiguo escenario de los amoríos de la reina Margot, y más tarde refugio de Oscar Wilde, l'Hôtel ha visto redoradas sus columnas neoclásicas gracias al artesano Alain Pouliquen, decorador de la Ópera de París. El sótano abovedado del establecimiento acoge en la actualidad unas termas romanas que incluyen piscina y hammam.

SHANGRI-LA
HOTEL PARIS

10, avenue d'Iéna
Trocadéro
Tel.: +33 (01) 53 67 19 98
www.shangri-la.com

Métro Iéna

Prices: $$$$

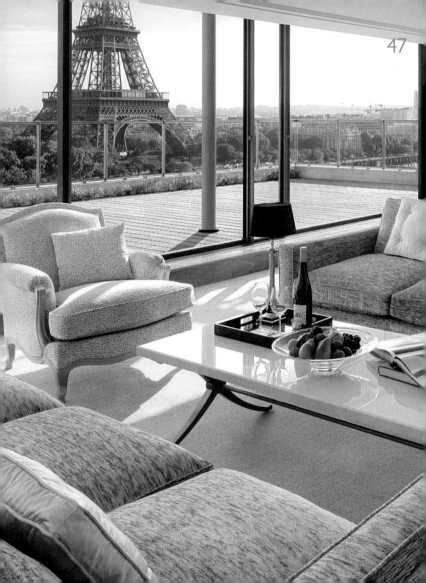

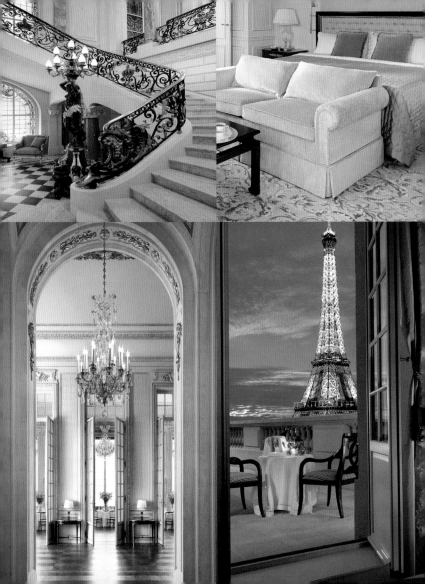

The windows of this former home of Prince Roland Bonaparte were first opened over Paris in 1896. The Shangri-La really does offer a rich selection of views across the French capital: the Seine, the Invalides, the Eiffel Tower… Guests can virtually carry out a tour of these Parisian monuments from inside the suites of this luxurious hotel with such majestic style. It is one of the few hotels to refrain from the temptations of contemporary design with the aim of preserving the traditional elegance of French hotels.

1896 blickte Prinz Roland Bonaparte aus den Fenstern seiner neu erbauten Residenz auf Paris. Heute genießen die Gäste des Shangri-La mannigfaltige Aussichten auf die Stadt: Seine, Invalidendom, Eiffelturm. Fast ließen sich die Pariser Sehens-würdigkeiten von den Suiten dieses Luxushotels aus besich-tigen. Das Hotel im Empire-Stil zählt zu den letzten, die sich nicht mit zeitgenössischem Design umgeben, sondern der Eleganz der französischen Hotels huldigen.

L'ancienne résidence du Prince Roland Bonaparte a ouvert ses fenêtres sur Paris en 1896. Le Shangri-La offre effectivement un riche panel de vues sur la capi-tale : la Seine, les Invalides, la Tour Eiffel… La visite des monuments parisiens pourrait presque s'effectuer depuis les suites de cet hôtel luxueux au style empire. L'un des derniers du genre à ne pas s'adonner aux joies du design contemporain pour perpétuer l'élégance hôtelière française.

La antigua residencia del príncipe Roland Bonaparte abrió sus ventanas a París en 1896. El Shangri-La, efectiva-mente, ofrece una amplia variedad de vistas de la ciudad: el Sena, los Invalides, la torre Eiffel… Casi podría uno efectuar las visitas a los monumentos parisinos desde las suites de este lujoso hotel de estilo Imperio, uno de los últimos de su género que no se ha dejado seducir por el diseño contemporáneo y perpetúa la elegancia de la hotelería francesa.

RESTAURANTS
+CAFÉS

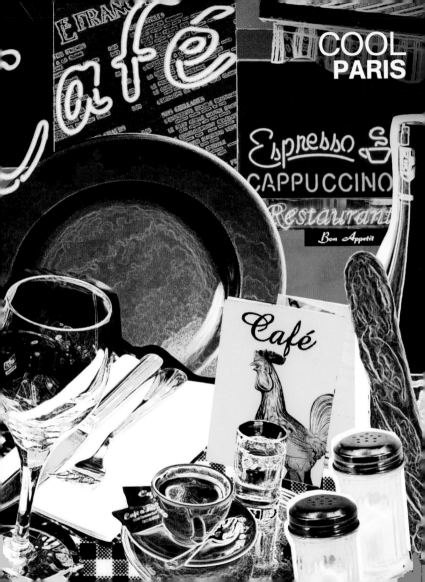

LE MODERNE

40, rue Notre-Dame-des-Victoires
Bourse
Tel.: +33 (01) 53 40 84 10

Mon–Fri noon to 3 pm
7 pm to 1 am
Sat 7 pm to 2 am

Métro Bourse

Prices: $$
Cuisine: French

Variations on a taupe and anthracite theme outlined in black; filtered light; floorboards. Jean-Luc Lefrançois chose sobriety as a backdrop for his 2D color scenes. Dark tables skimmed with monochrome light and complemented by refined vintages, the Moderne menu will wake up memories of forgotten flavors: medieval vegetables and traditional dishes. The finesse of this gold standard work delights eyes and taste buds at friendly prices.

Taupe- und Anthrazit-Farbtöne treffen auf Schwarz, gedämpftes Licht und dunklen Holzfußboden. Diese Nüchternheit bildet einen gelungenen Kontrast zu Jean-Luc Lefrançois' bunten Gerichten. An dunklen Tischen werden edle Weine kredenzt und auf hellen Tellern traditionelle Speisen serviert, beispielsweise nach mittelalterlicher Art zubereitetes Gemüse. Eine erlesene Meisterleistung zu fairen Preisen, ein Genuss für Augen und Gaumen.

Des variations de taupe et d'anthracite cernées de noir, une lumière tamisée et un plancher sombre. Jean-Luc Lefrançois a choisi la sobriété pour mettre en scène ses plats colorés. Parcourant les tables dans l'ombre de leur lumière monochrome, assorties de crus raffinés, les assiettes du Moderne réveillent les saveurs oubliées de légumes moyenâgeux et de plats traditionnels. La finesse de ce travail d'orfèvre ravit les yeux et la bouche, tout en restant à des prix raisonnables.

Variaciones sobre tonos pardos y antracita silueteados en negro, luces tamizadas, suelo de tarima. Jean-Luc Lefrançois ha optado por la sobriedad para presentar sus coloristas platos. Sobre las mesas oscuras, la luminosidad monocroma en refinados tonos crudos de los platos de Le Moderne despierta el sabor olvidado de legumbres medievales y platos tradicionales. La delicadeza de este trabajo de filigrana es un placer para la vista y el paladar, y todo a un precio asequible.

CAFÉ ARTCURIAL

7, rond-point des Champs-Élysées
Champs-Élysées
Tel.: +33962106419
www.artcurial.com

Mon–Sat 9.30 am to 7 pm

Métro Franklin D Roosevelt

Prices: $$$
Cuisine: French

At the heart of the chic hotel Dassault, Jean-Michel Wilmotte has envisaged a trademark decoration that adds a new dimension to the usual rumor surrounding the Champs-Élysées roundabout. The menu offered by Chef Julien Cranny changes each day to make every visit a surprise. But the extraordinary fabric of this restaurant prevents weariness and boredom, with its fusion of colonial and design influences.

Im exklusiven Hotel Dassault schuf Jean-Michel Wilmotte ein Ambiente, das die Gäste in eine andere Welt entführt und einen Puffer zu den Geräuschen des Kreisverkehrs an den Champs-Élysées bildet. Die Speisekarte des Küchenchefs Julien Cranny wechselt täglich, wodurch jeder Besuch zur Überraschung wird. In der außergewöhnlichen Kulisse des Restaurants, einer Mischung aus Kolonialstil und Design, kommt gewiss keine Müdigkeit oder Langeweile auf.

Au sein du très chic hôtel Dassault, Jean-Michel Wilmotte a imaginé une décoration tampon qui transporte dans une toute autre dimension que la rumeur du rond point des Champs-Élysées. La carte du chef Julien Cranny change tous les jours pour des visites chaque fois surprenantes. Mais l'extraordinaire toile de fond de ce restaurant, avec ses mélanges d'accents coloniaux et design, empêche à elle seule la lassitude et l'ennui.

En el interior del elegante hotel Dassault, Jean-Michel Wilmotte ha imaginado una decoración heterogénea que nos traslada a otra dimensión, lejos del tráfico de la rotonda de los Champs-Élysées. La carta del chef Julien Cranny cambia a diario, de modo que cada visita es una nueva sorpresa. Pero el extraordinario escenario del restaurante basta para desterrar el hastío y el aburrimiento, gracias a la combinación de pinceladas coloniales y de diseño.

MAKASSAR
LOUNGE &
RESTAURANT

39, avenue de Wagram
Champs-Élysées
Tel.: +33 (01) 55 37 55 37
www.makassarlounge.fr

Daily 7 pm to 2 am

Métro Ternes

Prices: $$$
Cuisine: Fusion

The best hidden secret of Hotel Renaissance, on avenue de Wagram, is to be found on the gardened side, with a large backlit glass counter. Makassar, with mahogany details and its green plants, immerses guests in an extrinsic serenity. The music and the materials, both with a hint of the exotic, provide the finishing touches to what can only be the result of its multicultural fabric, all stemming from a meeting of regional French cuisine and Indonesian gastronomy.

Das Juwel des in der Avenue de Wagram gelegenen Hotels Renaissance versteckt sich Richtung Garten hinter einer großen Glaswand. Das Makassar mit seinen Mahagoni- und Blätter-Elementen entführt seine Gäste in ein heiteres, außergewöhnliches Ambiente. Musik und exotisch angehauchte Materialien bilden die Kulisse einer bunten Auswahl an Gerichten – eine gelungene Mischung aus französischer Regionalküche und indonesischen Köstlichkeiten.

Ce que l'hôtel Renaissance, avenue de Wagram, cache de plus précieux se situe côté jardin, derrière une verrière large et lumineuse. Les touches d'acajou et de chlorophylle du Makassar plongent ses visiteurs dans une sérénité venue d'ailleurs. Musiques et matières teintées d'exotisme parachèvent ce qui sert de toile de fond à une carte multicolore, fruit de la rencontre entre cuisine régionale française et gastronomie indonésienne.

El secreto más preciado del hotel Renaissance, en la avenue de Wagram, se esconde en sus jardines tras una enorme vidriera. Las pinceladas de caoba y clorofila del Makassar sumergen al visitante en la serenidad de allende los mares. Músicas y materiales teñidos de exotismo ponen el toque final al escenario para una carta multicolor, fruto del encuentro entre la cocina regional francesa y la gastronomía indonesia.

OTH SOMBATH

184, rue du Faubourg Saint-Honoré
Champs-Élysées
Tel.: +33 (01) 42 56 55 55
www.othsombath.com

Mon–Sat noon to 3 pm
7 pm to 2 am

Métro Saint-Philippe-du-Roule

Prices: $$$
Cuisine: Thai

Sixties design put together by Patrick Jouin almost like a
fairytale, and the creations of one of the greatest stars of
Thai cuisine, come together in Paris' famous Golden Triangle.
Essentially, this is the restaurant that is considered the
best of its genre in Paris. Almost like an introduction to
this promise, the majestic ramp of the stairs appears like an
organ of light leading to the temple of Oth Sombath. It is
clearly worth discovering for its tastes, but also for the
eyes and the soul.

Im Goldenen Dreieck von Paris verbindet sich ein von
den Sixties inspiriertes und durch Patrick Jouin fabelhaft
zusammengestellites Design mit der Küche des thailändischen
Kochs und Medienstars Oth Sombath. Das Restaurant gilt
als bestes seiner Art in Paris. Von dieser Verheißung zeugt
bereits beim Betreten des Tempels das an eine Lichtorgel
erinnernde Treppengeländer. Ein Schmaus nicht nur für
den Gaumen, sondern auch für Augen und Seele.

Le design d'inspiration sixties composé comme une
fable par Patrick Jouin et la cuisine du plus médiatique
des chefs thaï se conjuguent dans le triangle d'or.
À la clé : le restaurant que l'on dit le meilleur de son
genre à Paris. Comme une introduction à telle pro-
messe, la rampe magistrale de l'escalier ressemble à
un orgue de lumière menant au temple d'Oth Som-
bath. A découvrir pour le goût bien sûr, mais aussi
pour les yeux et l'âme.

El diseño, de inspiración sesentera y compuesto como
en una ensoñación por Patrick Jouin, y la cocina del más
mediático de los cocineros tailandeses se dan la mano
en el triángulo de oro, en un restaurante que muchos
consideran el mejor de su género en París. Como si de
una introducción a esa promesa se tratase, la rampa
principal de la escalera parece un órgano de luz que
condujera al templo de Oth Sombath. Toda una reve-
lación para el gusto, qué duda cabe, pero también para
los ojos y el alma.

LE DERRIÈRE

69, rue des Gravilliers // Le Marais
Tel.: +33 (01) 44 61 91 95
www.derriere-resto.com

Daily noon to 2.30 pm
8 pm to 2 am (last call at midnight)

Métro Arts et Métiers

Prices: $$
Cuisine: French

The newest of the "restaurant-apartments" offers a variety of completely unique atmospheres: an actual family house. From table football to the bathroom, everything is cosy and homely. The cuisine—fresh, rich and traditional—is reminiscent of that of a good friend who likes to invite you over to dinner. Except that here, you can dine in his bedroom, his living room or even in his secret chamber! For a real discovery, don't forget to go rummaging through the cupboards!

Der jüngste Nachwuchs in der Familie der „Restaurant-Appartements" bietet ein ganz neuartiges Ambiente, denn das „Le Derrière" ist wie ein echtes Haus eingerichtet. Vom Tischfußball zum Bad strahlt alles eine große Gemütlichkeit aus. Die Küche setzt auf Frische, Leckereien und Tradition. Die Gäste fühlen sich wie bei einem guten Freund, der gern zu sich zum Essen einlädt. Allerdings darf der Besucher hier auch im Schlafzimmer speisen, im Wohnzimmer oder sogar im geheimen Zimmer. Um letzteres zu entdecken, lohnt es sich, in den Schränken zu stöbern.

BRUNO FRISONI'S
SPECIAL TIP

This location is still something of a secret, and the food is excellent!

Le dernier né des « restaurants appartements » propose un assemblage d'ambiances totalement inédit : une véritable maison. Du babyfoot à la salle de bain, tout est cosy. La cuisine, fraîche, gourmande et traditionnelle fait penser à celle de ce bon ami qui aime nous recevoir chez lui. Sauf qu'ici, on a le droit de dîner dans sa chambre à coucher, dans son salon, ou même dans sa pièce secrète. Pour la découvrir, un indice : fouillez dans les placards !

El benjamín de los "restaurantes-apartamento" propone una inédita combinación de ambientes: una verdadera casa. Todo en ella da sensación de hogar, desde el futbolín al cuarto de baño. La cocina, fresca, apetitosa y tradicional, nos hace pensar en la de ese buen amigo que nos acoge en su casa, con la diferencia de que aquí es posible comer en el dormitorio, en el salón e incluso en la salita secreta. Para descubrirla, un consejo: ¡estudie con atención los carteles!

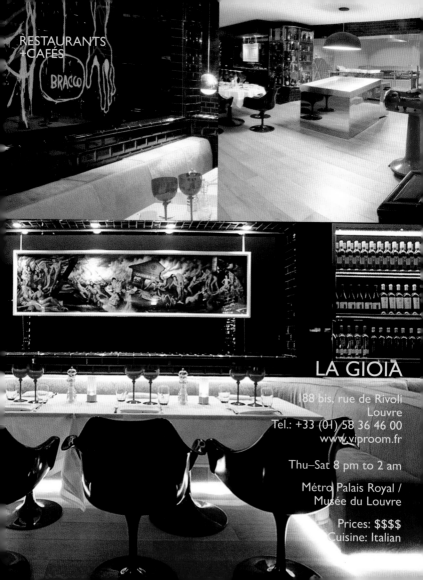

RESTAURANTS
+CAFÉS

BRACCO

LA GIOIA

188 bis, rue de Rivoli
Louvre
Tel.: +33 (01) 58 36 46 00
www.viproom.fr

Thu–Sat 8 pm to 2 am

Métro Palais Royal /
Musée du Louvre

Prices: $$$$
Cuisine: Italian

Sober decor and design thought out by Jean Roch, "Tulip" chairs by Eero Saarinen and Keith Haring and Basquiat on the walls to name but a few: welcome to the Gioia, the last of the prominent Parisian restaurants, straight out of Saint-Tropez. It's hard to believe that this cotton-soft atmosphere contains the dance floor for the adjoining VIP Room, over which plunges an immense, panoramic glass roof. Already a regular, Karl Lagerfeld himself has put together and added to the menu a salad bearing his name.

Nach Saint-Tropez nun Paris: Das Gioia mit seinem nüchternen, von Jean Roch entworfenen Design, „Tulpenstühlen" von Eero Saarinen und Werken von Künstlern wie Keith Haring und Basquiat an den Wänden zählt zurzeit zu den angesagtesten Restaurants der französischen Hauptstadt. In diesem abgeschirmten Ambiente lässt sich die Tanzfläche des angrenzenden VIP Room durch die riesige Glasplatte nur schwer erahnen. Auf der Speisekarte hat sich Karl Lagerfeld, ein großer Fan des Hauses, mit einer eigenen Salatkreation verewigt.

Décor sobre et design pensé par Jean Roch, chaises « Tulipe » d'Eero Saarinen, Keith Haring et Basquiat aux murs pour ne citer qu'eux : bienvenue à la Gioia, dernier restaurant parisien en vue, tout droit venu de Saint-Tropez. On devine à peine dans cette atmosphère ouatée le dancefloor du VIP Room attenant sur lequel plonge une immense verrière panoramique. Déjà adepte, Karl Lagerfeld a lui-même composé et inscrit à la carte une salade à son nom.

Decoración sobria, diseñada por Jean Roch; "sillas tulipánes" de Eero Saarinen; en las paredes, Keith Haring y Basquiat, entre otros muchos artistas: bienvenidos a la Gioia, el restaurante directamente transplantado desde Saint-Tropez que más ha dado que hablar últimamente a París. En su acolchado ambiente apenas se intuye la pista de baile del vecino VIP Room, sobre el que se abre una inmensa vidriera panorámica. Karl Lagerfeld, cliente asiduo, ha creado para la carta una ensalada que lleva su nombre.

RESTAURANTS
+CAFÉS

LE SAUT DU LOUP

107, rue de Rivoli // Louvre
Tel.: +33 (01) 42 25 49 55
www.lesautduloup.com

Daily noon to 2 am

Métro Pyramides

Prices: $$
Cuisine: French

Adjoining the Museum of Arts Décoratifs de Paris, the Saut du Loup is characterized by meticulous architecture and decor that is punctuated by iconic pieces of design, including the "Ant Chair" by Arne Jacobsen and the "Vegetal Chair" by the Bouroullec Brothers. But above all it is a garden with its carousel, overlooked by the patio terrace. An ideal break between exhibitions, everything is brought together in the simple and delicious menu.

Das im Pariser Museum für dekorative Künste gelegene Le Saut du Loup besticht vor allem durch seine elegante Architektur und Einrichtung. Meisterwerke des Designs wie die Sitzmöbel „Ameise" von Arne Jacobsen und der „Vegetal Chair" der Bouroullec-Brüder erfreuen die Besucher. Das wahre Prachtstück aber ist der Garten, der Jardin du Carrousel, der an die Terrasse des Restaurants grenzt und sich vorzüglich für eine kleine Pause zwischen zwei Ausstellungen eignet. Auf der Speisekarte stehen einfache, leckere Gerichte.

Annexe du musée des Arts Décoratifs de Paris, le Saut du Loup, c'est d'abord une architecture et une décoration soignées, ponctuées de monuments du design comme la « Fourmi » d'Arne Jacobsen et la « Vegetal Chair » des frères Bouroullec. Mais c'est surtout un jardin : celui du Carrousel, sur lequel s'ouvre la terrasse de l'établissement. La pause idéale entre deux expositions, le tout assorti à une carte simple et gourmande.

Anexo al museo de artes decorativas de París, el Saut du Loup, destaca en primer lugar por una arquitectura y una decoración muy cuidadas, jalonadas por monumentos del diseño como la "Hormiga" de Arne Jacobsen y la "Vegetal Chair" de los hermanos Bouroullec. Pero es, sobre todo, un jardín, el del carrusel, al que se abre la terraza del establecimiento. La pausa ideal entre dos exposiciones, perfectamente complementada con una carta simple pero muy apetecible.

YACHTS DE PARIS
DON JUAN II

Port Henri IV // Quais de Seine
Tel.: +33 (01) 44 54 14 70
www.yachtsdeparis.fr

Daily 8 pm to 1 am, and on request

Prices: $$$
Cuisine: French

An authentic yacht from the '50s, the luxurious Don Juan sails the Seine for those nostalgic and romantic souls. Refined cuisine created by the inventive Jean-Pierre Vigato files past the windows with their panoramic views. Filtered light falls on leather and velour furniture, harps and violins provide a musical backdrop. All the clichés are gathered together in this enchanting place, even the famous stop in front of the magnificent Eiffel Tower.

Die luxuriöse Jacht Don Juan aus den 50er Jahren lädt Nostalgiker und Romantiker zu einer Fahrt auf der Seine ein. Hinter den Panoramafenstern werden raffinierte Gerichte des innovativen Jean-Pierre Vigato serviert. Gedämpftes Licht fällt auf Möbel aus Leder und Samt, im Hintergrund spielen Harfe und Violinen. Sämtliche Klischees finden sich an diesem zauberhaften Ort bestätigt. Da darf ein Halt vor dem funkelnden Eiffelturm nicht fehlen.

Authentique yacht des années 50, le luxueux Don Juan parcourt la Seine pour les âmes nostalgiques et romantiques. La cuisine raffinée, composée par l'inventif Jean-Pierre Vigato, fait défiler ses assiettes devant les vitres panoramiques. Une lumière tamisée qui se pose sur des meubles de cuir et de velours, une harpe et des violons en fond sonore… Tous les clichés se rassemblent en ce lieu enchanteur, jusqu'à la fameuse halte devant la Tour Eiffel scintillante.

Yate auténtico de la década de los años 50, el lujoso Don Juan surca el Sena con espíritus nostálgicos y románticos a bordo. La refinada cocina concebida por el ingenioso Jean-Pierre Vigato hace desfilar sus platos ante las ventanas panorámicas. La luz tamizada se posa sobre muebles de cuero y terciopelo, con un fondo sonoro de harpas y violoncelos. Todos los clichés se materializan en este espacio encantador, incluida una parada frente a la torre Eiffel iluminada.

LA FIDÉLITÉ

12, rue de la Fidélité // République
Tel.: +33 (01) 47 70 19 34
www.lafidelite.com

Mon–Sat 8 pm to 1 am

Métro Gare de l'Est

Prices: $
Cuisine: French

Fidélité opens as if it were an ionic pillared chapel where the concept of brasseries is said to have been invented. Within its crypt, the jukebox becomes the guiding symbol for those night owls missing the days when they could smoke inside. Friends find each other and meet under the classically molded pillars of this new generation bistro in an easygoing atmosphere. Despite the majestic nature of this gigantic establishment, the tables are intimate, and the atmosphere is conducive to flirting.

Mit seinen ionischen Säulen mutet das Fidélité wie eine Kapelle an, als wolle es das Konzept der Brasserie neu definieren. An der Jukebox in der Krypta kommen Erinnerungen an die Raucherzeiten auf. Unter den Stuckverzierungen dieses Bistros der neuen Generation lassen sich in entspannter Atmosphäre alte Freunde treffen und neue finden. Trotz der Erhabenheit, die der riesige Raum ausstrahlt, umgibt die Tische ein intimes, zum Flirten einladendes Ambiente.

La Fidélité s'ouvre comme une chapelle aux colonnes ioniques où le concept de brasserie aurait été réinventé. Dans sa crypte, le jukebox s'impose en totem des noctambules nostalgiques de la cigarette. Les amis se retrouvent et se rencontrent sous les moulures de ce bistrot nouvelle génération dans une ambiance décomplexée. Malgré le cadre majestueux de ce lieu gigantesque, les tables sont intimes, et l'atmosphère propice au flirt.

La Fidélité se abre como una capilla de columnas jónicas en el que se ha reinventado el concepto de la restauración. En la cripta, el jukebox adquiere el carácter de tótem para los noctámbulos nostálgicos del cigarrillo. Los amigos se citan bajo las molduras de este restaurante de nueva generación en un ambiente sin complejos. Pese a la majestuosidad de tan gigantesca superficie, las mesas gozan de intimidad y el ambiente invita al coqueteo.

CAFÉ DE FLORE

172, boulevard Saint-Germain
Saint-Germain-des-Prés
Tel.: +33 (01) 45 48 55 26
www.cafedeflore.fr

Daily 7 am to 2 am

Métro Saint-Germain-des-Prés

Prices: $$
Cuisine: French

Named after "Flore", the statuette that stood next to the café around 1887, this café was something of an "office" for the brightest minds of France, from Jacques Prévert to André Breton. Café de Flore is a Parisian institution not to be missed. Lovers' haunt for Simone de Beauvoir and Jean-Paul Sartre, the Flore remains an exceptional hideout, and is home, every September, to the literary prize Prix de Flore, presented in this truly historical setting to deserving young authors.

Benannt nach „Flore", der Statuette, die 1887 in unmittelbarer Nähe des Cafés stand, diente das Café den hellsten Köpfen Frankreichs, von Jacques Prévert bis André Breton, als eine Art Büro. Das Café de Flore ist eine Institution in Paris, die man sich nicht entgehen lassen sollte. Einst Treffpunkt des Liebespaares Simone de Beauvoir und Jean-Paul Sartre ist das Flore auch heute noch ein außergewöhnlicher Zufluchtsort, in dem in historischem Ambiente jeden September junge Autoren mit dem Literaturpreis Prix de Flore ausgezeichnet werden.

Du nom de « Flore » comme la petite statue dont le café était voisin vers 1887, ce « Bureau » des esprits français les plus brillants, de Jacques Prévert à André Breton, est une institution parisienne incontournable. Repère des amours de Simone de Beauvoir et Jean-Paul Sartre, le Flore demeure un refuge d'exception. Chaque année, au mois de septembre, y est décerné dans une ambiance chargée d'histoire, le Prix de Flore, un prix littéraire qui récompense les jeunes auteurs.

Bautizado en alusión a la pequeña estatua del mismo nombre instalada cerca del local hacia 1887, esta "oficina" de los más brillantes ingenios franceses, de Jacques Prévert a André Breton, es hoy una ineludible institución parisina. Escenario de los amores de Simone de Beauvoir y Jean-Paul Sartre, el Flore acoge cada año un acontecimiento de excepción. En el mes de septiembre se concede en tan ínclito marco el Prix de Flore, un galardón literario para autores jóvenes.

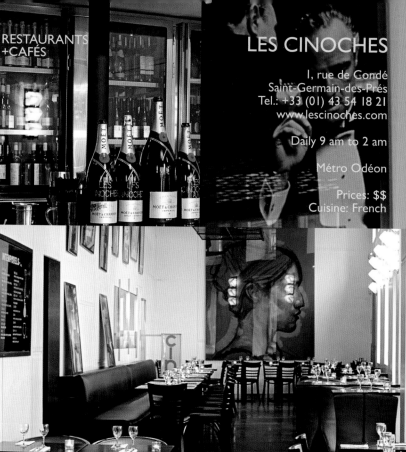

RESTAURANTS
+CAFÉS

LES CINOCHES

1, rue de Condé
Saint-Germain-des-Prés
Tel.: +33 (01) 43 54 18 21
www.lescinoches.com

Daily 9 am to 2 am

Métro Odéon

Prices: $$
Cuisine: French

Beneath the arcades of the beautiful art house cinema in Saint-Germain, waiters and waitresses scurry back and forth bearing plates. This is where Les Cinoches have imposed their own classic, modern and pure style, everywhere from the decor to the kitchens. Each Sunday evening indie films are projected onto the great white walls of the restaurant, while on other days the only screen to remind us of the primary function of this building is the panoramic window allowing a glimpse into the kitchens.

In einem Programmkino in Saint-Germain wird unter den Arkaden eines bezaubernden Saals zu Tisch gebeten. Von der Dekoration bis zur Küchenausstattung zeichnet sich alles durch einen einfachen, modernen und feinen Stil aus. Jeden Sonntagabend werden Autorenfilme auf die großen weißen Wände des Restaurants projiziert. An den anderen Tagen ist die einzige Leinwand, die noch an die frühere Funktion des Gebäudes erinnert, das große zur Küche gehende Panoramafenster.

Les assiettes défilent sous les arcades d'une très jolie salle de cinéma d'art et d'essais de Saint-Germain. C'est là que Les Cinoches ont imposé leur style classique, moderne et épuré, de la décoration aux cuisines. Tous les dimanches soir, des films d'auteurs sont projetés sur les grands murs blancs du restaurant. Les autres jours, le seul écran pour rappeler la fonction première de l'édifice est la fenêtre panoramique donnant sur les cuisines.

Los platos desfilan bajo los arcos de una bella sala de arte y ensayo en Saint-Germain. En Les Cinoches se ha sabido imponer un estilo clásico, moderno y depurado que se extiende desde la decoración hasta la cocina. Todos los domingos por la tarde se proyectan películas de autor sobre los grandes muros blancos del restaurante. El resto de días, la única pantalla que recuerda la función primigenia del edificio es la ventana panorámica abierta a la cocina.

TOKYO EAT

13, avenue du Président Wilson
Trocadéro
Tel.: +33 (01) 47 20 00 29
www.palaisdetokyo.com

Daily noon to 1 am

Métro Alma / Marceau

Prices: $$
Cuisine: Fusion

With bare concrete and visible metallic beams leading all the way to the kitchens, this temple of contemporary and experimental art is the Palais de Tokyo. Comfortable armchairs, upholstered in boiled wool, and round tables are witness to the surprising, traditional and yet innovative meals coming out from the kitchens. And to pay tribute to such a site of contemporary innovation, the mural paintings have been entrusted to that artist of wall painting, Bernard Brunon.

Unverputzter Beton und auffällige Stahlträger ziehen sich bis in die Küche des Palais de Tokyo, dem Zentrum für zeitgenössische und experimentelle Kunst. An runden Tischen und bequemen Sesseln aus Walkstoff werden außergewöhnliche Gerichte serviert, die gekonnt Tradition und Innovation verbinden. Die Wandgemälde stammen von dem Künstler und Gebäudemaler Bernard Brunon, angefertigt zu Ehren dieses Ortes zeitgenössischen Schaffens.

ELISABETH QUIN'S SPECIAL TIP

Just like the Samaritaine department store, there's always something happening at Palais de Tokyo! Crazy shopping, on-trend exhibitions, evening entertainment, parties, workshops for kids: it always ends up at Tokyo Eat, the most inventive eatery of the rive droite.

Béton brut et poutres métalliques apparentes se prolongent jusque dans les cuisines du temple de l'art contemporain et expérimental, le Palais de Tokyo. Confortables fauteuils de laine bouillie et tables rondes voient défiler des assiettes surprenantes, traditionnelles et pourtant innovantes. Et pour rendre hommage à ce site de création contemporaine, les peintures murales ont été confiées à l'artiste peintre en bâtiment Bernard Brunon.

El cemento visto y vigas metálicas descubiertas se extienden hasta la cocina del Palais de Tokyo, templo del arte contemporáneo y experimental. Confortables sillones de lana hervida y mesas redondas son testigos del ir y venir de platos sorprendentes, tradicionales y al mismo tiempo innovadores. En homenaje a este centro de creación contemporánea, la decoración de las paredes ha sido confiada al artista de brocha gorda Bernard Brunon.

SHOPS

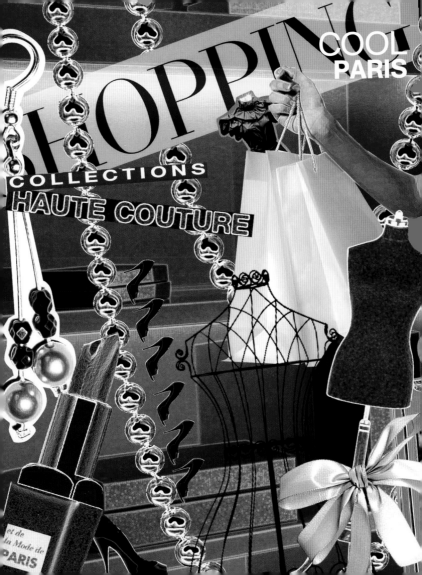

LOUIS VUITTON

101, avenue des Champs-Élysées
Champs-Élysées
Tel.: +33 (01) 53 57 24 00
www.louisvuitton.com

Mon–Sat 10 am to 8 pm
Sun 11 am to 7 pm

Métro George V

Prices: $$$$

The most important piece of architecture associated with the illustrious trunk-maker is without a doubt his boutique on the Champs-Élysées designed by Eric Carlson. With a surface of 20,000 sq. ft., it is the world's largest luxury boutique, remarkable for having been designed without distinct levels, following rather an architectural plan of multi-levelled spiral terraces which lead up to a 66 ft. high atrium. This interior setting, finished to perfection, bears the signature of Peter Marino.

Die vom Architekten Eric Carlson konzipierte Boutique auf den Champs-Élysées gilt unbestritten als das beeindruckendste architektonische Meisterwerk des berühmten Koffermachers. Das größte Luxusgeschäft der Welt umfasst eine Fläche von 1 800 m², wobei es keine Etagen gibt: Terrassen, die über mehrere Ebenen ansteigen, winden sich spiralförmig um ein 20 m hohes Atrium in der Mitte. Diese perfekt inszenierte Innengestaltung stammt von Peter Marino.

BRUNO FRISONI'S
SPECIAL TIP

Louis Vuitton
on the Champs-Élysées
is incredible, and
enormous! Check out
the cultural center on
the top floor.

L'œuvre architecturale majeure de l'illustre malletier est sans conteste sa boutique des Champs-Élysées, conçue par l'architecte Eric Carlson. Avec ses 1 800 m² de surface, le plus grand magasin de luxe au monde a la particularité d'être imaginé sans étages, mais selon un promenade architectural multi-niveaux de terrasses en spirale conduisant à un atrium de 20 m de hauteur. Cet espace intérieur aux finitions parfaites est signé Peter Marino.

La principal presencia del ilustre fabricante de maletas es sin duda la boutique sita en los Champs-Élysées, concebida por el arquitecto Eric Carlson. Dotado de 1 800 m² de superficie, la mayor tienda de lujo del mundo destaca por haber sido concebida siguiendo las líneas de un paseo arquitectónico organizado en una serie de terrazas estructuradas en torno a un patio de 20 m de alto. Este espacio interior de perfectos acabados lleva la firma de Peter Marino.

SHOPS

L'ÉCLAIREUR

8, rue Boissy d'Anglas
Concorde
Tel.: +33153430370
www.leclaireur.com

Daily 11 am to 7 pm

Métro Concorde

Prices: $$$

Any fashionista who is not a fan of conventional shopping must know of l'Éclaireur, with its high profile selection and bespoke tailoring service. But the boutique on rue Boissy d'Anglas has added a new dimension to the art of window shopping. Visionary architecture and design by the Belgian artist Arne Quinze and the architects at SAQ come together, creating a setting where each and every customer will experience their very own sensory adventure. At night the boutique becomes an avant-garde experimental gallery.

Alle Anhänger einer Mode abseits des Mainstreams kennen L'Éclaireur, schätzen die stylische Auswahl und den persönlichen Service. Die Boutique in der Rue Boissy d'Anglas bietet jedoch eine ganz neue Dimension. Hier verbinden sich visionäre Architektur und Design des belgischen Künstlers Arne Quinze und des Büros SAQ zu einer Inszenierung, die bei jedem Kunden ein ganz eigenes sensorisches Erlebnis auslöst. Nachts verwandelt sich die Boutique in eine Galerie für avantgardistische und experimentelle Kunst.

BRUNO FRISONI'S SPECIAL TIP

For fashionable individuals, sometimes their approach is almost too intellectual. But this is still where the greatest new talents are displaying their flair!

Tous les adeptes de mode hors sentier connaissent l'Éclaireur, sa sélection pointue et son service sur-mesure. Mais la boutique de la rue Boissy d'Anglas offre une dimension nouvelle au lèche vitrine. Architecture et design visionnaires de l'artiste belge Arne Quinze et du cabinet SAQ se marient dans une mise en scène où chaque client vit sa propre expérience sensorielle. La nuit, la boutique se métamorphose en galerie avant-gardiste et expérimentale.

Todos los adeptos a la moda lejos de la corriente principal conocen l'Éclaireur por lo especializado de su oferta y su servicio a medida. Pero la tienda de la rue Boissy d'Anglas abre además una nueva dimensión a irse de escaparates. El visionario diseño y arquitectura del artista belga Arne Quinze y el despacho SAQ se han combinado en una puesta en escena en la que cada cliente se sumerge en una experiencia sensorial propia. Por las noches, la tienda se transforma en una galería vanguardista y experimental.

KILIWATCH

64, rue Tiquetonne // Étienne Marcel
Tel.: +33 (01) 42 21 17 37
www.espacekiliwatch.fr

Mon–Sat 9 am to 6 pm

Métro Étienne Marcel

Prices: $$

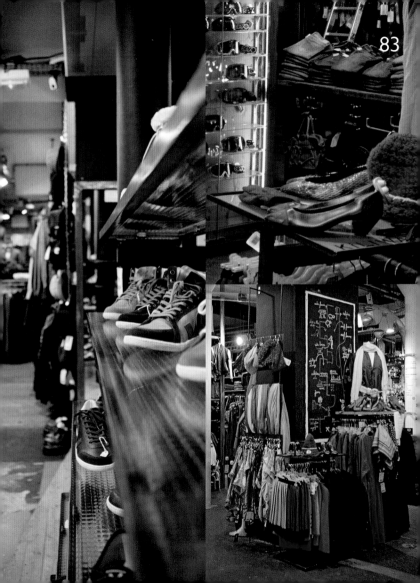

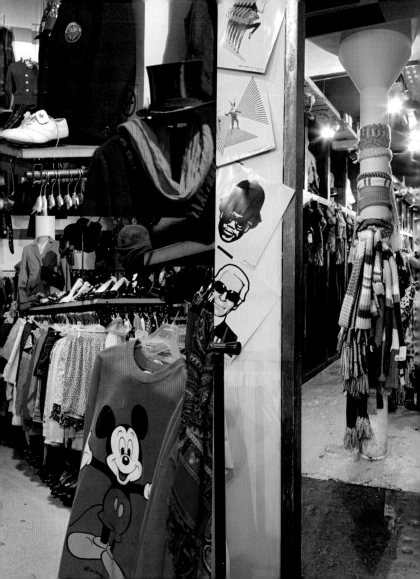

In the official quartier of high-quality Parisian vintage can be found the most celebrated long corridor of Parisian hype. Kiliwatch, temple to retro fashion, was conceived as a long corridor where vintage pieces, cleaned and meticulously classified, are laid out to tempt the hand of even the most particular of fashionistas. Put simply, you can find anything here, from a rare book to a Hawaiian shirt: such a mix of genres is in fact the key concept behind this establishment, which sits at the cutting edge of the fashion scene.

Im offiziellen Viertel des guten Pariser Vintage befindet sich der wohl berühmteste lange Flur, um den ein wahrer Hype entstanden ist: Kiliwatch – der Tempel der Retromode. In einem langen Korridor warten fein säuberlich sortierte Klamotten auf die Anspruchsvollsten unter den Modebegeisterten. Von der Buchrarität zum Hawaiihemd lässt sich hier einfach alles finden. Eine bunte Mischung, ganz nach dem Motto dieses angesagten Modehauses.

Dans le quartier officiel du bon vintage parisien se situe le plus célèbre allée de la hype parisienne : Kiliwatch, le temple de la mode rétro, est conçu comme un long corridor où les vêtements, propres et triés avec minutie, sont offerts aux mains des modeux les plus exigeants. On y trouve simplement de tout, du livre rare à la chemise hawaïenne : le mélange des genres est le mot d'ordre de cette maison à la pointe de la mode.

En un barrio de por sí conocido por su oferta vintage se extiende el más célebre pasillo parisino consagrado a la moda de antaño: Kiliwatch, el templo del estilo retro, ha sido diseñado como un largo corredor en el que las prendas, limpias y minuciosamente seleccionadas, se ofrecen a los ojos y manos de los más exigentes. Allí puede uno encontrar casi de todo, desde un libro raro a una camisa hawaiana: la mezcla de géneros está a la orden del día en este local, verdadera vanguardia de la moda.

GALERIES LAFAYETTE

40, boulevard Haussmann
Grands Boulevards
Tel.: +33 (01) 42 82 34 56
www.galerieslafayette.com

Mon–Sat 9.30 am to 8 pm
Thu 9.30 am to 9 pm

Métro Chaussée d'Antin / La Fayette

Prices: $$$$

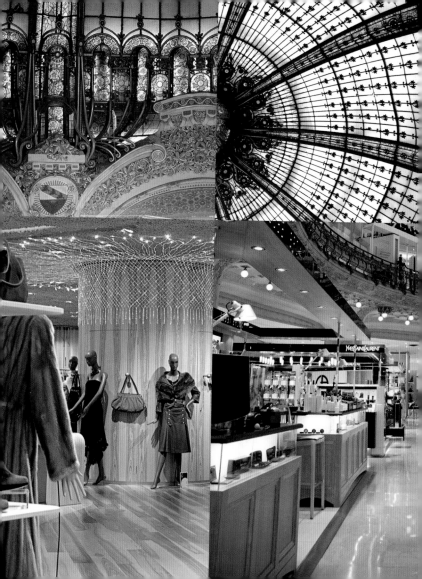

Since 1912, luxury goods at Galeries Lafayette have been being bathed with a particular type of golden light, beaming out from the great, 110 ft. high dome, its metal framework sculpted with Art nouveau motifs. A surface of 30 acres ringed by rounded gold-leaf coated balconies, housing fashion labels and decorations of the highest prestige, which have often been discovered by the shop itself: Yves Saint Laurent, Pierre Cardin, Cacharel.

Seit 1912 präsentieren „die Galerien" ihre Luxuswaren in einem ganz einzigartigen goldenen Licht. Dieses entsteht durch die 33 m hohe große Glaskuppel, deren Metallkonstruktion Jugendstilmotive zieren. Mit Blattgold dekorierte runde Balkone umgeben die 120 000 m² große Verkaufsfläche, auf der sich die renommiertesten Marken aus den Bereichen Mode und Dekoration präsentieren. Einige von ihnen wurden von dem Geschäft selbst entdeckt, beispielsweise Yves Saint Laurent, Pierre Cardin oder Cacharel.

Depuis 1912, « Les Galeries » inondent leurs luxueuses marchandises d'une lumière dorée bien particulière. Celle ci provient de la grande coupole de 33 m de hauteur, dont la charpente métallique est ornée de motifs art nouveau. 120 000 m² cerclés de balcons ronds dorés à la feuille d'or abritent les marques mode et déco les plus prestigieuses qui furent souvent découvertes par la célèbre maison : Yves Saint Laurent et Pierre Cardin et Cacharel.

Una luz dorada muy particular inunda desde 1912 "las Galerias" y el género que en ellas se expone. La luz proviene de la gran cúpula de 33 m de alto, una estructura metálica tachonada de motivos modernistas. Varios balcones redondos y adornados con pan de oro rodean los 120 000 m² del local, en el que están disponibles las marcas más prestigiosas de moda y decoración, muchas de ellas descubiertas por el propio establecimiento: Yves Saint Laurent, Pierre Cardin, Cacharel.

anatómicals
do, do, do
undo
another do
the partied
too much
pack

in the
name of
the
lather
orange
and lime
body
cleanser

you
need a
bloomin
shower

BUBBLEWOOD

4, rue Elzévir // Le Marais
Tel.: +33 (01) 44 78 03 86
www.bubblewood.com

Daily 11.30 am to 8 pm
closed on Tue

Métro Saint-Paul or
Chemin Vert

Prices: $$

DON'T MAKE WAR

LOVE IN PEACE

The most selective boutique of the Marais is something like a travel diary—the concrete result of a family's passion. Father, mother, son and daughter have traveled the world, and notably Scandinavia, searching for unknown and fantastic brands. The decor, reminiscent of a patchwork case, oscillates between neo-baroque and untamed urbanity. The concept is simple: everything that can't be found anywhere else should be available here—and this promise is kept.

Wer durch die stylischste Boutique des Marais-Viertels schlendert, begibt sich auf Reisen. Zu verdanken haben die Kunden das der Leidenschaft einer Familie: Auf der Suche nach originellen, noch unbekannten Marken haben Vater, Mutter, Sohn und Tochter die ganze Welt, allen voran die skandinavischen Länder, bereist. Die schmucke Einrichtung gleicht einem Patchwork und verbindet Neobarock mit einem unkomplizierten urbanen Stil. Das Konzept ist simpel: Hier gibt es alles, was sonst nirgendwo zu haben ist. Versprochen.

La boutique la plus pointue du Marais se découvre comme un carnet de voyage, matérialisé par la passion d'une famille. Père, mère, fils et fille ont parcouru le monde, notamment les pays scandinaves, à la recherche de marques inconnues et géniales. Le décor, composé comme un écrin en patchwork, oscille du néobaroque au brut urbain. Le concept est simple : que tout ce qui ne se trouve nulle part ailleurs soit ici. Promesse tenue.

La tienda más a la vanguardia del Marais resulta ser todo un diario de viaje hecho posible por la pasión de una familia. Padre, madre e hijos han recorrido el mundo, y especialmente los países escandinavos, en busca de marcas desconocidas y geniales. La decoración aprovecha retales de aquí y allá y oscila entre el neobarroco y el marginalismo urbano. El concepto es simple: reunir aquí todo lo que no es posible encontrar en otro lugar. Y la tienda cumple lo que promete.

MARIAGE FRÈRES

30, rue du Bourg-Tibourg
Le Marais
Tel.: +33 (01) 42 72 28 11
www.mariagefreres.com

Daily 10.30 am to 7.30 pm

Métro Hôtel de Ville

Prices: $$$

Set up in 1854, the venerable maison de thé has been expanding its empire for the last 25 years into the four corners of the Earth. But its Darjeeling tea doesn't have the same taste as when it is served in the colonial interior of its Parisian boutiques, with shelves and shelves of those famous little black boxes carpeting the walls. The Marais salon de thé, in particular, is a vibrant invitation to travel the world—a voyage in search of the cherry scented Sakura, or the blue night flowers of Earl Grey French Blue.

Seit einem Vierteljahrhundert erweitert das 1854 gegründete ehrwürdige Teehaus sein Imperium auf allen Teilen der Erde. Der Darjeeling lässt sich aber immer noch am besten in einem der im Kolonialstil eingerichteten Pariser Teesalons genießen, deren Wände die berühmten kleinen schwarzen Dosen zieren. Vor allem der Salon im Marais weckt die Lust auf eine Reise durch die Kirscharomen der Sakura und die nachtblauen Blüten des Earl Grey French Blue.

Fondée en 1854, la vénérable maison de thés étend depuis 25 ans son empire aux quatre coins du monde. Mais son Darjeeling n'a pas la même saveur que servi dans le décor colonial de ses boutiques parisiennes, aux murs tapissés de la fameuse petite boîte noire. Le salon de thé du Marais en particulier est une invitation vivante au voyage. Un voyage au fil des senteurs de cerise du Sakura, ou des fleurs bleues nuit du Earl Grey French Blue.

Fundada en 1854, esta venerable casa especializada en tes empezó hace 25 años a expandir su imperio por todo el mundo. Sin embargo, el Darjeeling tiene un sabor diferente cuando se sirve en el esplendor colonial de sus instalaciones parisinas de paredes cubiertas de punta a punta por las famosas cajitas negras. El salón de té del Marais, en especial, es una invitación en toda regla a embarcarse en un viaje hacia los aromas de Sakura y el oscuro azul de las flores del Earl Grey French Blue.

 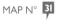

BOUTIQUE
CHANTAL
THOMASS

211, rue Saint-Honoré // Louvre
Tel.: +33 (01) 42 60 40 56
www.chantalthomass.fr

Mon–Sat 11 am to 7 pm

Métro Tuileries or Pyramides

Prices: $$$

Empress of French lingerie, Chantal Thomass chose rue Saint-Honoré to set up home for her lace and frills. Like a Wedgwood sculpted sweet box, the boutique, designed by Christian Ghion, is suggestive of all the mischief concealed into the corsets of this "tall dark lady". Visits to this charming boudoir will open your eyes, amongst all the garters, satin bustiers and suspenders.

Chantal Thomass, Kaiserin der Dessous, setzt in der Rue Saint-Honoré edle Spitzen und feine Stoffe gekonnt in Szene. Die von Christian Ghion konzipierte Boutique erinnert an eine Bonbondose à la Wedgwood und lässt bereits das Maliziöse erahnen, das in den Korsetts des Hauses steckt. Dieses charmante Boudoir mit seinen Miedern, Satin-BHs und Strumpfbändern weiß zu verführen.

Impératrice de la lingerie française, Chantal Thomass a choisi la rue Saint-Honoré pour accueillir ses dentelles et froufrous. Comme une boîte à bonbons sculptée façon Wedgwood, la boutique imaginée par Christian Ghion laisse déjà présager toute la malice qui se glisse dans les corsets de la célèbre « longue dame brune ». La visite de ce charmant boudoir fait tourner la tête, entre guêpières, corbeilles de satin et jarretières.

Emperatriz de la lencería francesa, Chantal Thomass optó por la rue Saint-Honoré para presentar sus puntillas y encajes. Como si de una bombonera de porcelana se tratase, el local diseñado por Christian Ghion permite adivinar toda la malicia que se oculta entre los corsés de la famosa "dama morena" de la canción de Moustaki. Una visita a este encantador gabinete repleto de corpiños, sostenes de satén y ligueros no puede dejar indiferente a nadie.

COLETTE

213, rue Saint-Honoré // Louvre
Tel.: +33 (01) 55 35 33 90
www.colette.fr

Mon–Sat 11 am to 7 pm

Métro Tuileries

Prices: $$$

Nobody would have bet on this boutique, founded in 1997 by Colette and Sarah Lerfel, mother and daughter. Yet the 8,000 sq. ft. area on rue Saint-Honoré, fitted out by French architect Arnaud de Montigny, has become a reference in the fashion and design world. Innovative even to its kitchens, with its famous water bar, Colette was set up as a precursor to the fashionable mind-set of the early adopters.

Die 1997 von Mutter Colette Lerfel und Tochter Sarah gegründete Boutique fand zunächst wenig Beachtung. Inzwischen hat sich der 700 m² große, vom französischen Architekten Arnaud de Montigny konzipierte Laden in der Rue Saint-Honoré in der Mode- und Designwelt längst einen Namen gemacht. Innovativ bis hin zur Küche mit seiner berühmten Wasserbar genießt Colette unter den trendigen Early Adopters den Ruf als Vorreiterin.

ELISABETH QUIN'S SPECIAL TIP

I feel so old! For me Colette is the name of one of the greatest Romantics in France. For everyone else, it's the temple to the hype. Often copied, but never equaled.

Personne n'avait parié sur cette boutique fondée en 1997 par Colette et Sarah Lerfel, mère et fille. Pourtant, l'espace de 700 m² rue Saint-Honoré, aménagé par l'architecte français Arnaud de Montigny, est devenu une référence dans le domaine de la mode et du design. Innovant jusque dans ses cuisines avec son fameux bar à eaux, Colette s'est érigé en précurseur dans l'esprit des early adopters branchés.

En 1997, nadie daba un duro por la tienda fundada por Colette y Sarah Lerfel; hoy, sin embargo, los 700 m² del establecimiento de la rue Saint-Honoré, decorados por el arquitecto francés Arnaud de Montigny, se han convertido en punto de referencia en el mundo de la moda y el diseño. Innovadora hasta en la cocina, gracias a su famoso bar de aguas, Colette es un local pionero, muy del gusto de su público, acomodado y adelantado a las tendencias.

Financier

1,65 €

LADURÉE

16, rue Royale // Madeleine
Tel.: +33 (01) 42 60 21 79
www.laduree.fr

Mon–Thu 8.30 am to 7.30 pm
Fri–Sat 8.30 am to 8 pm
Sun & Holidays 10 am to 7 pm

Métro Concorde or Madeleine

Prices: $$$

The very first salon de thé in France has been exciting the taste buds for nearly 150 years. Decorated with rich wooden paneling, frescos of merry-making cherubs, this original boutique is as beautiful as it is appetising. The trademark product of the salon, the macaron—that small, round and colourful treat, available in 20 different flavours—was famously brought before the camera by Sofia Coppola in the film "Marie-Antoinette". A delight which is to be savoured, guilt-free!

Seit fast 150 Jahren verwöhnt der allererste französische Teesalon nun schon die Sinne seiner Gäste. Holzvertäfelungen und Fresken, die Engelchen als Leckermäulchen zeigen, sorgen für ein schönes Ambiente und regen den Appetit an. Das typische Produkt des Hauses ist der Macaron, ein kleiner runder Keks, den es in verschiedenen Farben und etwa 20 Geschmacksrichtungen gibt und der im Film „Marie-Antoinette" von Sofia Coppola farbenfroh in Szene gesetzt wurde. Eine Köstlichkeit, die es ohne Reue zu genießen gilt!

Le tout premier salon de thé Français régale les sens depuis près de 150 ans. Décoré de riches boiseries, de fresques mettant en scène des angelots gourmands, la boutique d'origine est aussi belle qu'appétissante. Produit emblématique de la maison, le macaron, ce petit biscuit rond et coloré, décliné dans une vingtaine de parfums, a été mis en scène dans le « Marie-Antoinette » de Sofia Coppola. Un délice à déguster sans complexes.

El primer salón de té abierto en Francia es desde hace 150 años un regalo para los sentidos. Decorado en costosas maderas y frescos de angelotes golosos, el local es un primor que despierta el apetito. El producto emblemático del establecimiento es el macaron, una galletita redonda de vivos colores confeccionada en más de 20 aromas, y que quizá conozcan por haberlo visto en la película "Marie-Antoinette" de Sofia Coppola. Un placer a degustar, sin complejos.

JEANNE A

42, rue Jean-Pierre Timbaud
République
Tel.: +33 (01) 43 55 09 49

Thu–Mon 10.30 am to 10.30 pm

Métro Parmentier

Prices: $

In an elegant boutique in the 20th arrondissement, Jeanne A has been able to draw from all the spirit of this classic area. The "épicerie for eating" brings together all aspects in a familial, convivial atmosphere: catering, canteen and high-quality boutique. The selection of goods is done with care: delicate wines, Berthier preserves, Italian condiments and so much more. Jeanne A is certainly the most refined way to go food shopping!

Die elegante Boutique Jeanne A im 20. Arrondissement spiegelt den Geist dieses typischen Viertels gekonnt wider. In ungezwungenem und geselligem Ambiente präsentiert sich ein Ensemble aus Feinkostgeschäft, Kantine und Delikatessenladen. Die Warenauswahl erfolgt mit Sorgfalt: feine Weine, Berthier-Konfitüren, italienische Gewürze und vieles mehr. Ein Besuch bei Jeanne A ist die wahrhaft kultivierteste Art, seine Einkäufe zu erledigen.

Dans une élégante boutique du XXe arrondissment, Jeanne A a su saisir tout l'esprit de ce quartier typique. L' « épicerie à manger » rassemble les genres dans un esprit familial et convivial : traiteur, cantine, et boutique de produits fins. En termes de marchandises, la sélection a été soignée : vins délicats, confitures Berthier, condiments italiens et bien d'autres délices. Jeanne A est certainement le moyen de plus raffiné de faire ses courses.

En su elegante boutique del distrito 20 de París, Jeanne A ha sabido condensar el espíritu de este barrio tradicional. El "colmado / casa de comidas" combina géneros en un ambiente familiar y acogedor: restaurante, cantina y tienda de delicatessen. La selección de productos está muy cuidada: vinos de calidad, confituras Berthier, condimentos italianos… No cabe duda: nada como Jeanne A para hacer la compra con elegancia y estilo.

LA PÂTISSERIE DES RÊVES

93, rue du Bac
Saint-Germain-des-Prés
Tel.: +33 (01) 42 84 00 82
www.lapatisseriedesreves.com

Tue–Sat 9 am to 8 pm
Sun 9 am to 4 pm

Métro Rue du Bac or
Sèvres / Babylone

Prices: $$

In La Pâtisserie des Rêves (French for "the patisserie of dreams"), flavors are shrouded in mystery, as if they were from a perfumer's secret laboratory. Philippe Conticini, the mischievous chemist at the source of this ode to decadence, reveals and reminds your palate of traditional and timeless recipes. Tarte Tatin (a variety of apple pie), éclair au chocolat and brioche du dimanche matin (a sweet French breakfast bread) are the stars that shine the brightest in their flavorsome surroundings, where any indulgence is allowed.

Wie im geheimen Labor eines Parfümeurs befinden sich in der Pâtisserie der Träume die Köstlichkeiten unter einer Glocke. Philippe Conticini, humorvoller Chemiker und Komponist dieser Hymne auf die Nascherei, verwöhnt den Gaumen mit traditionellen, zeitlosen Leckereien. Tarte Tatin, Éclair au chocolat und Brioche am Sonntagmorgen sind die gefeierten Stars in einer bonbonfarbenen Kulisse, in der Genuss groß geschrieben wird.

Dans La Pâtisserie des Rêves, on garde les saveurs sous cloche, comme dans le laboratoire secret d'un parfumeur. Philippe Conticini, le facétieux chimiste à l'origine de cet hymne à la gourmandise, révèle les papilles et leur rappelle la mémoire des recettes traditionnelles et intemporelles. Tarte Tatin, éclair au chocolat et brioche du dimanche matin sont les vedettes belles et bonnes de ce décor acidulé où tous les écarts sont permis.

En la "pastelería de los sueños", los sabores se guardan bajo una campana, como en el laboratorio secreto de un perfumista. Philippe Conticini, el simpático químico responsable de este monumento al buen yantar, descubre y recuerda a las papilas gustativas el sabor de recetas tradicionales e intemporales. Tarte Tatin, éclair au chocolat y brioches de domingo son las deliciosas estrellas de este conjunto levemente ácido en el que todos los experimentos están permitidos.

BATHROOM GRAFFITI

98, rue de Longchamp
Trocadéro
Tel.: +33 (01) 47 04 23 12
www.bathroomgraffiti.com

Mon 11 am to 7 pm
Tue–Sat 10 am to 7 pm

Métro Trocadéro

Prices: $$

When you need to find an original gift, all Parisians have just one name on their lips: where chic and kitsch are king, where you're sure to find that mischievous and cunning object to brighten up your day. Bathroom Graffiti always writes its diverse shopping list well in advance. Fashion and kitchen utensils sit side by side natural trinkets and gadgets in this uninhibited bazaar, where you're sure to leave smiling.

Wenn es um originelle Geschenke geht, hat der Pariser eine geniale Lösung: Bathroom Graffiti – ein Ort, an dem Chic und Kitsch regieren und sich mit Sicherheit ein ulkiger, raffinierter Gegenstand finden lässt, der den Alltag verschönert. Das vielseitige Sortiment ist stets einen Schritt voraus. Mode, Küchenutensilien, Krimskrams und technische Spielereien ergeben ein buntes Durcheinander, das jedem ein Lächeln auf die Lippen zaubert.

Lorsqu'il s'agit de trouver un cadeau original, le Parisien n'a qu'un nom à la bouche : là où le chic et le kitsch sont rois, où l'on est sûr de trouver l'objet malicieux et astucieux qui égaiera le quotidien. Bathroom Graffiti compose toujours avec une longueur d'avance sa shopping-list métissée. Mode et ustensiles de cuisine côtoient avec naturel bibelots et gadgets dans ce bazar décomplexé, dont on est sûr de ressortir le sourire aux lèvres.

A la hora de encontrar un regalo original, los parisinos remiten siempre al mismo lugar, un local en el que reinan el chic y el kitsch, donde es posible encontrar ese objeto inusitado con el que animar la ocasión. La abigarrada oferta de Bathroom Graffiti consigue adelantarse siempre a nuestros deseos. La moda y los utensilios de cocina coexisten sin complejos con bicocas y artilugios varios en este bazar, de donde el cliente sale siempre con una sonrisa en los labios.

 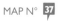

CLUBS, LOUNGES +BARS

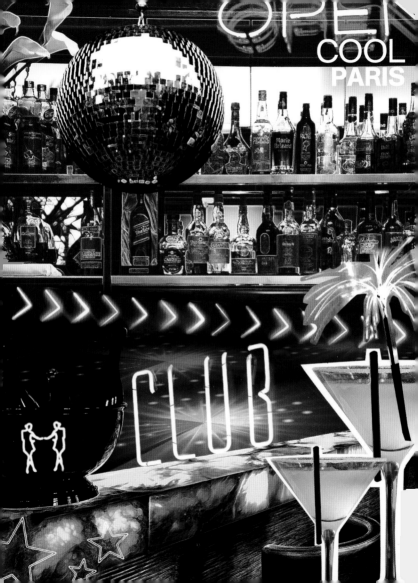

CLUBS,
LOUNGES
+BARS

BARRIO LATINO

46, rue du
Faubourg Saint-Antoine
Bastille
Tel.: +33 (01) 55 78 84 75
www.buddha-bar.com

Daily noon to 2 am

Métro Bastille

Prices: $$

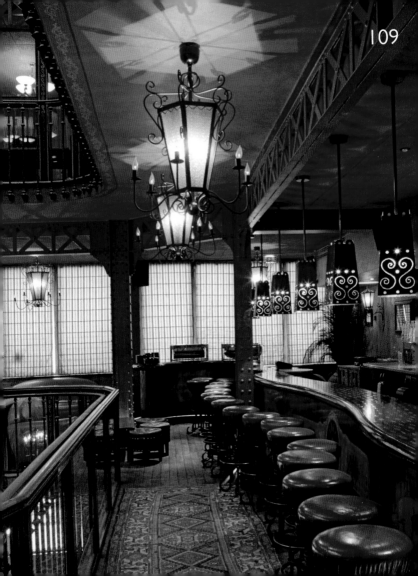

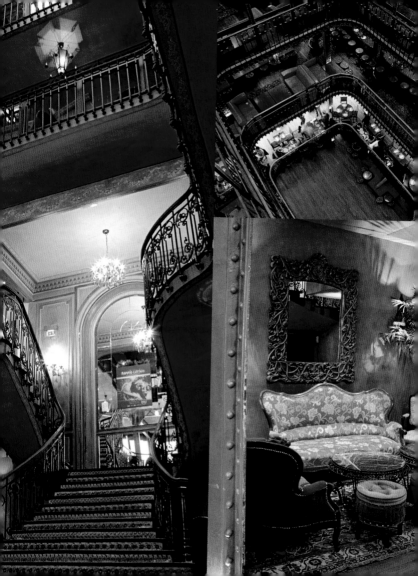

Like a piece of Cuba at the heart of the Bastille, 32,000 sq. ft. of pure splendor and a 100% Havana attitude. The spectacular staircase going up to all four floors of this mythical edifice, a listed historical monument, invites you to come and discover all the different worlds of Barrio Latino. Tapas and salsa dancing, a winter garden in the patio, a cigar bar and club chairs…all the flavours of South America are to be found set within this metallic structure, the work of Gustave Eiffel.

Ein Stück Kuba im Herzen der Bastille: 3 000 m² purer Glanz und hundertprozentiges Havanna-Feeling. Die spektakuläre Treppe, die den Gast in alle vier Stockwerke dieses mythischen Gebäudes führt, steht unter Denkmalschutz und lädt dazu ein, alle unterschiedlichen Welten des Barrio Latino zu erkunden. Tapas und Salsa, Patio mit Wintergarten, Zigarrenbar und Klubsessel … alle Geschmackserlebnisse Südamerikas können in dieser metallenen Struktur von Gustave Eiffel wiedergefunden werden.

Cuba au cœur de la Bastille : 3 000 m² de faste pur et d'esprit 100% Havane. L'escalier grandiose desservant les quatre niveaux de cet édifice mythique, qui est classé aux monuments historiques, invite à découvrir les différents univers du Barrio Latino. Tapas et dancefloor salsa, jardin d'hiver en patio, bar à cigares et fauteuils clubs…toutes les saveurs de l'Amérique du Sud dans un écrin à la structure métallique signée Gustave Eiffel.

Cuba en el corazón de la Bastilla: 3 000 m² de suntuosidad pura y espíritu ciento por ciento habanero. Una grandiosa escalinata comunica los cuatro niveles de este edificio mítico, monumento histórico protegido, e invita a descubrir los diferentes universos del Barrio Latino. Tapas y pista de baile para la salsa, jardín de invierno en el patio interior, salas para amantes de los cigarros, dotadas de los más confortables sillones: todos los sabores de América del Sur, encuadrados en una bellísima estructura metálica obra de Gustave Eiffel.

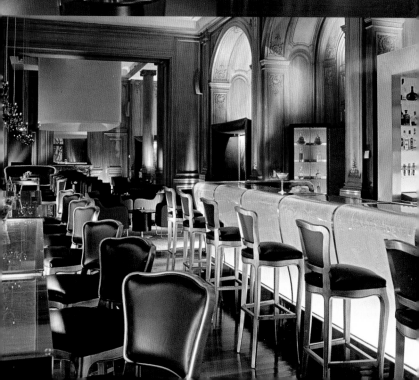

CLUBS,
LOUNGES
+BARS

BAR DU PLAZA

25, avenue Montaigne
Champs-Élysées
Tel.: +33 (01) 53 67 66 00
www.plaza-athenee-paris.com

Daily 6 pm to 2 am

Métro Alma / Marceau

Prices: $$$

Inaugurated in 1911 on one of the most beautiful avenues of Paris, the Plaza is home to a timeless bar, with influences from somewhere between innovation and the luxury of times gone by. Paneling, columns and armchairs, all in resolutely contemporary designs, are lit up by the Murano chandeliers designed exclusively for this legendary hotel. The counter at the bar, unique in its class, is lit up through its rounded and sculpted atrium, and was awarded the prize for the "Best Bar Experience" in 2007.

Das Plaza ist 1911 in einer der schönsten Avenues von Paris eingeweiht worden und beherbergt eine zeitlose Bar, die beeinflusst wurde von Innovation und dem Luxus vergangener Zeiten. Die Wandbekleidung, Säulen und Armsessel sind durchgehend zeitgenössisch gestaltet und werden von Murano-Kronleuchtern in Szene gesetzt, die exklusiv für dieses legendäre Hotel entworfen wurden. Der Tresen der Bar, die 2007 mit dem Preis „Best Bar Experience" ausgezeichnet wurde, ist einzigartig in seiner Klasse und leuchtet durch seinen abgerundeten gläsernen Korpus hindurch.

Inauguré en 1911 sur l'une des plus belles avenues de Paris, le Plaza abrite un bar intemporel, entre innovation et luxe passé. Boiseries, colonnes et fauteuils au design résolument contemporain sont éclairés par des lustres Murano dessinés en exclusivité pour cet hôtel de légende. Le comptoir, unique en son genre, s'illumine au travers de son ventre de verre bombé et sculpté, et a été récompensé du prix « best bar experience » en 2007.

Inaugurado en 1911 en una de las más hermosas avenidas de París, el hotel Plaza alberga un bar intemporal en el que se conjugan la innovación y el lujo tradicional. Lámparas de cristal de Murano, diseñadas en exclusiva para el legendario hotel, alumbran las maderas, columnas y sillones de diseño firmemente contemporáneos del establecimiento. La barra, única en su género, ilumina desde dentro sus formas abombadas y esculpidas; en 2007 mereció el galardón "best bar experience".

LA MAISON BLANCHE

15, avenue Montaigne
Champs-Élysées
Tel.: +33 (01) 47 23 55 99
www.maison-blanche.fr

Mon–Thu noon to 2 pm
8 pm to 11 pm
Fri–Sat 8 pm to 5 am

Métro Franklin D Roosevelt or
Alma / Marceau

Prices: $$$

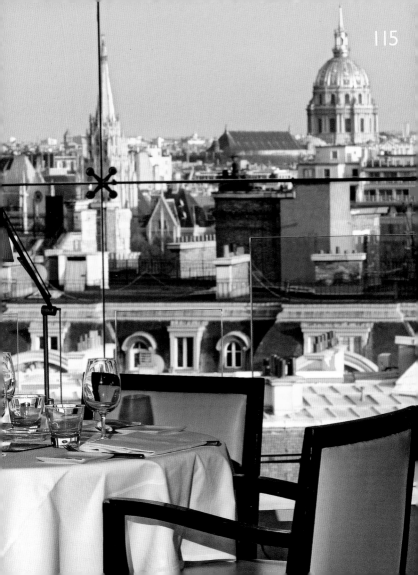

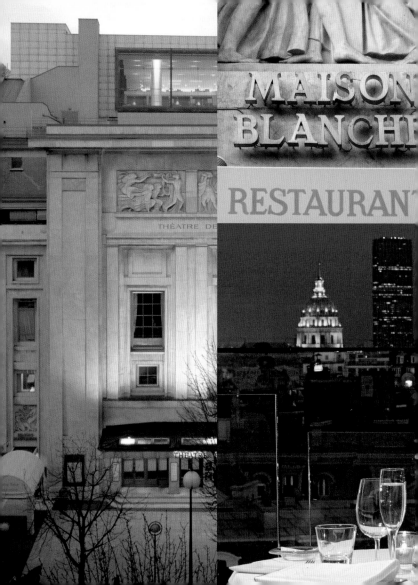

In 1913, the outline of the very chic avenue Montaigne was redrawn with the construction of a building in armored concrete—the "Théâtre des Champs-Élysées". Designed by the architect August Perret in association with sculptor Antoine Bourdelle, it was classed as a historic monument in 1957. The Maison Blanche found a way to integrate itself, perching on a bridge above the edifice to give a plunging view of Paris out from its enormous bay windows.

Im Jahre 1913 erhält die vornehme Avenue Montaigne durch den Bau des „Théâtre des Champs-Élysées" ein neues Antlitz. Das vom Architekten Auguste Perret gemeinsam mit dem Bildhauer Antoine Bourdelle entworfene Gebäude aus Stahlbeton steht seit 1957 unter Denkmalschutz. Dennoch ermöglichte eine ausgeklügelte Konstruktion die Angliederung des Maison Blanche an das Theater: Das Restaurant thront hoch oben auf dem Dach des Gebäudes. Seine große Glaswand bietet den Gästen eine herrliche Sicht auf die tief unten liegende Stadt.

BRUNO FRISONI'S SPECIAL TIP

Fabulous view of Parisian hotspots, all in white, white, white!

En 1913, la très chic avenue Montaigne est redessinée par un bâtiment de béton armé, le Théâtre des Champs-Élysées. Conçu par l'architecte Auguste Perret, en collaboration avec le sculpteur Antoine Bourdelle, il est classé monument historique en 1957. La Maison Blanche trouve alors une solution pour s'intégrer au théâtre : se percher sur un pont au dessus de l'édifice, pour offrir une vue plongeante sur Paris depuis son immense baie vitrée.

En 1913, la elegantísima avenida Montaigne se vio redefinida por un edificio de cemento armado, el "Théâtre des Champs-Élysées". Concebido por el arquitecto Auguste Perret en colaboración con el escultor Antoine Bourdelle, en 1957 fue declarado monumento histórico. La Maison Blanche encontró entonces la manera de integrarse en el teatro: instalarse sobre un puente por encima del edificio para ofrecer una vertiginosa vista de París desde sus inmensos ventanales.

CLUBS,
LOUNGES
+BARS

BLITZ
TEQUILA BAR

40, avenue Pierre 1er de Serbie
Champs-Élysées
Tel.: +33 (01) 47 20 77 77
www.blitztequila.com

Tue–Sat 9 pm to 2 am

Métro Georges V

Prices: $$$

How could you guess that behind this Haussmann façade of the 8th arrondissement hides the most prized location in Paris? Upholstered in black, the bar is entirely devoted to the famous Blitz tequila from 1920s Berlin. Favourite haunt of Parisian jet-setters or of those just passing through, black is the sole colour in this exclusive bar, which has a feel of the Prohibition about it. Only the round fresco of record covers and cherry tomato reds are there to remind us that the world outside is still filled with colour!

Wer würde vermuten, dass sich hinter dieser für das 8. Arrondissement typischen Haussmann-Fassade einer der beliebtesten Orte der Metropole verbirgt? Die ganz in schwarz gehaltene Bar ist der berühmten Tequilamarke Blitz aus dem Berlin der Goldenen Zwanziger gewidmet. Hier trifft sich der Jetset – Pariser und Durchreisende – in einem von Schwarz dominierten Ambiente, das an die Prohibition erinnert. Lediglich die Schallplattencover und die roten Kirschtomaten bringen etwas Farbe ins Spiel.

Comment deviner que cette façade haussmannienne type du 8e arrondissement cache l'endroit le plus prisé de Paris ? Tapissé de noir, le bar est voué tout entier à la fameuse tequila Blitz du Berlin des années 20. Repaire des jet-setters de Paris et de passage, le noir est la couleur exclusive de ce bar ambiance Prohibition. Seule une fresque de 33 tours et la rougeur des tomates cerises nous rappelle que le monde extérieur est coloré !

Difícilmente podría uno imaginar que tras la convencional fachada de este edificio del Distrito Octavo se esconde el local más en boga de todo París. Tapizada en negro, la barra está dedicada en su totalidad al famoso tequila Blitz del Berlín de la década de 1920. Punto de encuentro de la gente guapa de dentro y fuera de la ciudad, el color negro prima en este bar, cuya ambientación recuerda la de los locales de la Prohibición. Tan solo el friso de portadas de discos y el rojo de los tomates cherry introducen en el local los colores del mundo exterior.

CLUBS,
LOUNGES
+BARS

L'ARC

12, rue de Presbourg
Champs-Élysées
Tel.: +33 (01) 45 00 78 70
www.larc-paris.com

Restaurant: Mon–Sat noon to 3 pm
7 pm to 2 am
Club: Thu–Sat from 11.30 pm

Métro Charles-de-Gaulle / Étoile

Prices: $$$

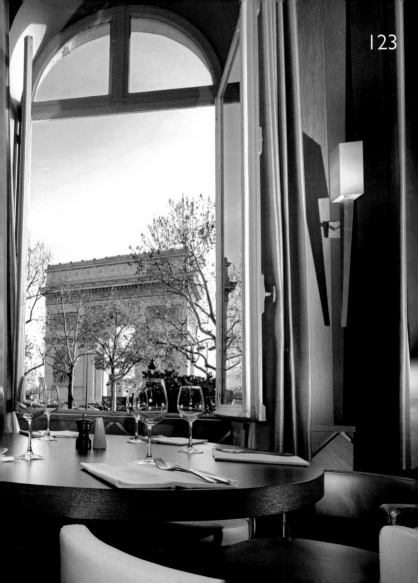

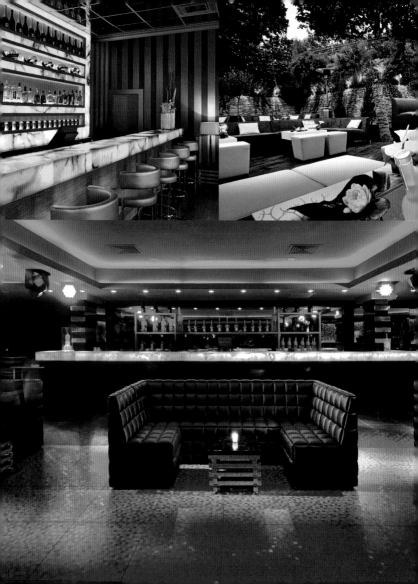

Grandiose decor in many forms, L'Arc accumulates superlatives. Its entrance doorway on the "Place de l'Étoile" and its Haussmannian frame mean that the clinking of champagne flutes can be heard floating through the air. Within, the architect Samy Chams does not allow the eyes any respite: trompe-l'œil set in molds, a constellation of glitter balls, a mirrored ceiling and a neon lounge. As a result it is naturally the most refined of clientele that has selected l'Arc as their favorite nightspot.

Ein großartiges, abwechslungsreiches Design macht das Arc zu einem Ort der Superlative. Das Klingen der Champagnergläser ist bereits am Eingang des im Hauss-mann-Stil errichteten Gebäudes an der Place de l'Étoile zu vernehmen. Das vom Architekten Samy Chams gestal-tete Innere gönnt den Augen keine Ruhe: Diskokugeln, Deckenspiegel, von Verzierungen eingefasste optische Täuschung, Neonbeleuchtung. Hier trifft sich die Crème de la Crème der Nachtschwärmer.

Décor grandiose aux formes multiples, l'Arc cumule les superlatifs. Pas de porte sur la Place de l'Étoile et ossa-ture haussmannienne laissent déjà filtrer le tintement des coupes de champagne. Intra muros, l'architecte Samy Chams ne laisse aucun répit à nos pupilles : trompe-l'œil serti de moulures, constellation de boules disco, plafond miroir, salon-néon. La plus raffinée des clientèles a donc naturellement élu domicile nocturne à l'Arc.

Grandioso decorado de formas cambiantes, L'Arc es una suma de superlativos. La puerta no se encuentra en la plaza de l'Étoile; la fachada, de estilo Haussmann, se tiñe ya de los tonos de las copas de champán. En el interior, el arquitecto Samy Chams no da tregua a nuestras pupi-las: molduras decoradas en trompe-l'œil, constelaciones de bolas de discoteca, techo de espejos, salas de neones. Como no podía ser de otro modo, la más refinada de las clientelas ha acabado instalándose en L'Arc.

CLUBS,
LOUNGES
+BARS

LE RENARD

12, rue du Renard // Le Marais
Tel.: +33 (01) 42 71 86 27
www.renardrenard.com

Tue–Sat 8.30 pm to 4 am

Métro Hôtel de Ville

Prices: $$

In this former Parisian theatre with decor drawing from the roaring twenties, singing and dancing allows the switched on diners to unwind. Dishes are served against background music from some well-known and some less well-known artists. This is because, on top of the mind-blowing art deco framing and delicate Asian cuisine, le Renard is also probably the world's most chic Karaoke bar. Revived by Rasmus Michaud in 2010, le Renard provides a breath of fresh air to the world of dinner-theatre.

Ein ehemaliges Pariser Theater der Goldenen Zwanziger bildet die Kulisse für ein angesagtes Abendessen bei Gesang und Tanz. Serviert werden die Gerichte zur Musik bekannter und verkannter Künstler. Das Renard bietet nicht nur eine beeindruckende Art Déco-Gestaltung sowie eine vorzügliche asiatische Küche, es gilt zudem als die wahrscheinlich schickste Karaokebar der Welt. Von Rasmus Michaud 2010 wieder zum Leben erweckt, bringt das Renard frischen Wind in die Tradition der Dinnershows.

Dans le décor années folles d'un ancien théâtre parisien, le chant et la danse décomplexent les dîners branchés. On sert les assiettes sur fond de musique d'artistes connus ou méconnus. Car en plus d'un époustouflant cadre Art déco de 1920 et d'une cuisine asiatique délicate, le Renard est probablement le karaoké bar le plus chic au monde. Ressuscité par Rasmus Michaud en 2010, il donne un nouveau souffle à la tradition des diners spectacles.

En el marco de un antiguo teatro parisino de los años veinte, el baile y las canciones desinhiben a la elegante concurrencia. La comida se sirve con fondo de música de intérpretes famosos—o no tan famosos. Y es que, más allá del asombroso estilo Art déco y de la delicada cocina asiática, el Renard es posiblemente el karaoke más chic del mundo. Resucitado por Rasmus Michaud en 2010, el Renard ha insuflado nuevos ánimos a la tradición de la cena espectáculo.

CLUBS,
LOUNGES
+BARS

VIP ROOM

188 bis, rue de Rivoli // Louvre
Tel.: +33 (01) 58 36 46 00
www.viproom.fr

Wed–Sat 10 pm to 5 am

Métro Palais Royal / Musée du Louvre

Prices: $$$

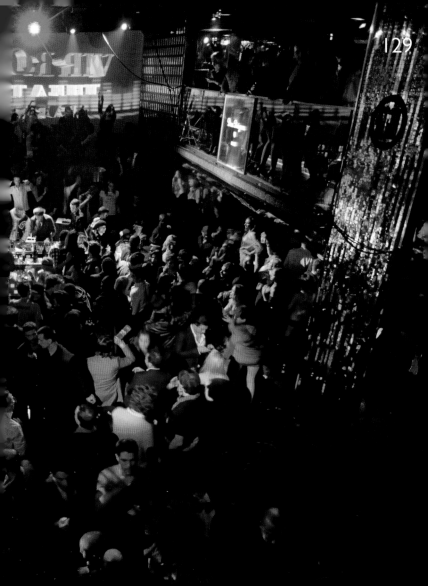

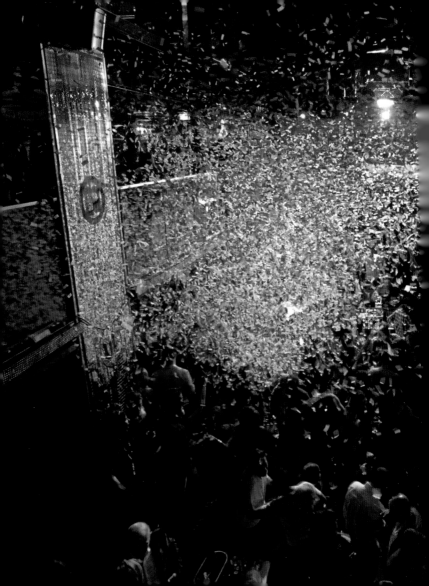

Parisian night-owls have chosen their home next to the Louvre, beneath the arcades of the luxurious rue de Rivoli. Jean Roach, pope of the night, conceived this area where all excess comes together: 11,000 sq. ft. illuminated with neon lights, the 13 ft. long bar encircled by magnums. Straight benches and black lacquered tables are there in answer to the circular podium studded with light, dominated by the glass-fronted mezzanine of the adjoining restaurant.

Die Pariser Nachtschwärmer zieht es bevorzugt in die Nähe des Louvre, unter die Arkaden der luxuriösen Rue de Rivoli; dorthin, wo der König der Nacht Jean Roch einen Ort der Superlative geschaffen hat. Die 1 000 m² große Fläche ist neonbeleuchtet, an der 4 m langen Bar werden die Magnumflaschen herumgereicht. Geradlinige Bänke und schwarz lackierte Tische treffen auf ein mit Lichtern durchsetztes Rundpodest, das vom verglasten Zwischengeschoss des angrenzenden Restaurants überragt wird.

Les noctambules parisiens ont élu domicile à côté du Louvre, sous les arcades de la luxueuse rue de Rivoli. Jean Roch, le pape de la nuit, a imaginé cet espace où toutes les démesures se conjuguent : 1 000 m² éclairés de néons où les magnums circulent sur le bar de 4 m de long. Banquettes rectilignes et tables laquées noires répondent au podium circulaire bizarre de lumière, dominé par la mezzanine vitrée du restaurant attenant.

Los noctámbulos parisienses han decidido instalarse cerca del Louvre, bajo los arcos de la lujosa rue de Rivoli. Jean Roch, sumo sacerdote de la noche, ha imaginado un espacio en el que se conjugan todos los excesos: 1 000 m² iluminados por el neón, donde las botellas magnum circulan por los 4 m de la barra. Banquetas rectilíneas y mesas lacadas en negro son el contrapunto al podio circular ribeteado de luces y dominado por los ventanales del restaurante contiguo.

CHEZ MOUNE

54, rue Jean-Baptiste Pigalle
Pigalle
Tel.: +33 (01) 45 26 64 64
www.chezmoune.fr

Daily 11 pm to 5 am

Métro Pigalle

Prices: $

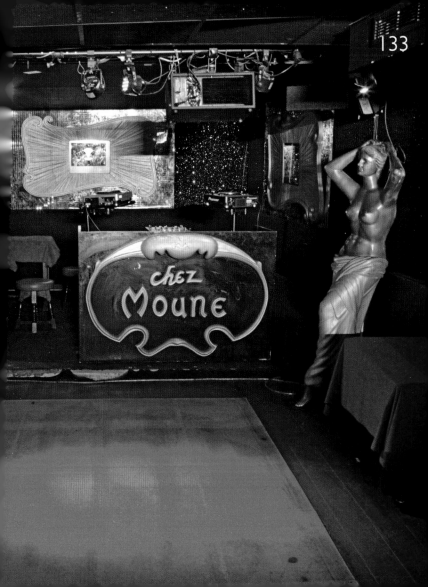

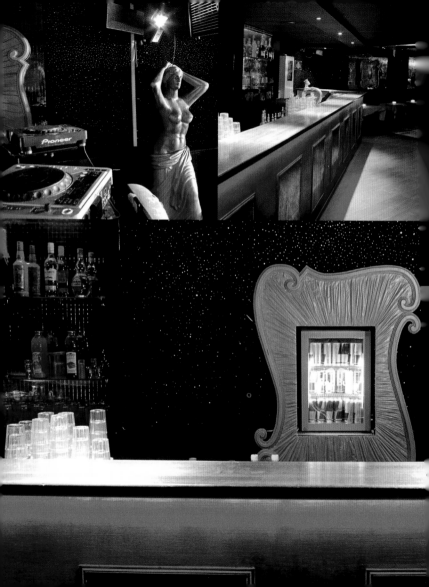

Here the Guetta DJs have been sacrificed to an altar of high class music, surrounded by rococo decor in Chez Moune: this is where, in 1936, Parisian lesbians found a nocturnal refuge, and today the place welcomes a mixed clientele, eclectic and trendy. Soirées are based around the menu of the week, ranging from stripteases to karaoke. Exactly what is needed to pay homage to a historically sulfurous area: Pigalle.

Der im Rokoko-Stil gehaltene Club ist bekannt für seine ausgewählt gute Musik. 1936 Treffpunkt für lesbische Nachtschwärmerinnen, feiert hier heute ein breitgefächertes, bunt gemischtes und hippes Publikum. Jede Woche wird ein abwechslungsreiches Programm geboten, von Striptease-Abenden bis zu Karaoke-Nächten. Eine Hommage an das seit jeher verruchte Viertel Pigalle.

ELISABETH QUIN'S SPECIAL TIP

Opened at the time of the Front populaire, Chez Moune was THE lesbian cabaret of Paris. The girl-likes-girl bar has become a girl-likes-boy-likes-girl club, and they all love the music—truly a place for music lovers.

Pour les adeptes de musique pointue, l'autel du bon son est dressé au sein du décor entre rococo et Art déco de Madame Moune. Là où, en 1936, les lesbiennes parisiennes avaient trouvé refuge nocturne, l'établissement accueille désormais une clientèle mixte, éclectique et branchée. Les soirées dépendent du menu de la semaine et varient du strip-tease au karaoké. De quoi rendre hommage à un quartier historiquement sulfureux : Pigalle.

Los amantes de la música de vanguardia están de enhorabuena: un altar consagrado a la buena música se alza en el ambiente entre rococó y Art déco de Madame Moune. Local lésbico fundado en 1936, las camareras atienden en traje y corbata a una clientela ecléctica y con posibles. La velada depende del menú de la semana, y puede incluir desde un strip-tease a una sesión de karaoke, rindiendo así homenaje a un barrio tradicionalmente pecaminoso y tolerante: Pigalle.

MAP N° 45

CAFÉ DE L'HOMME

17, place du Trocadéro // Trocadéro
Tel.: +33 (01) 44 05 30 15
www.restaurant-cafedelhomme.com

Daily noon to 2 am

Métro Trocadéro

Prices: $$$

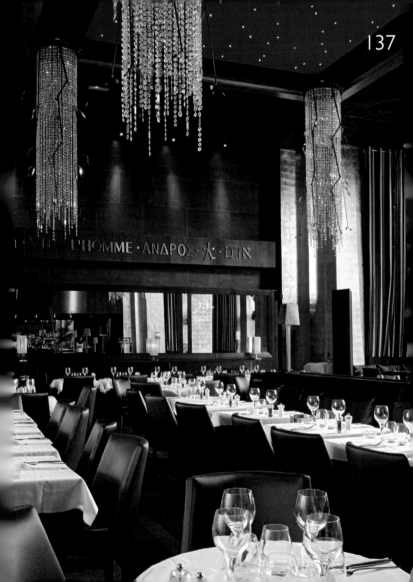

L'HOMME · ΑΝΔΡΟΣ · אדם

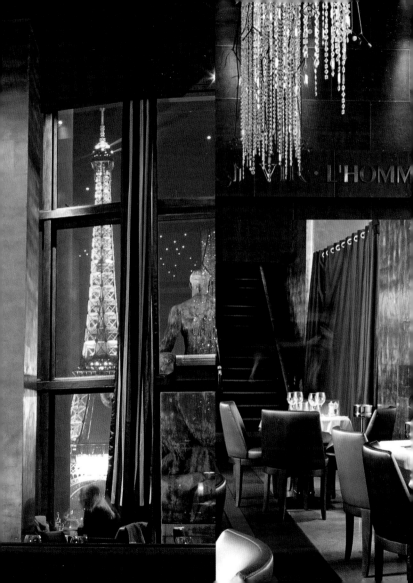

In the magical setting of the museum of the same name, the Café de l'Homme offers a flawless view onto the "Iron Lady", Paris' most famous landmark. Decorated in a contemporary style somewhere between Bauhaus and Art Nouveau, it will tempt you into tasting the rich and inspiring menu. In the summer, a vast outdoor terrace accentuates the breathtaking view of the Eiffel Tower, surveyed by one of the largest guardian figures of the Musée de l'Homme.

In der magischen Umgebung des gleichnamigen Museums bietet das Café de l'Homme eine makellose Sicht auf die „eiserne Dame", das berühmteste Wahrzeichen der Stadt. In zeitgenössischem Stil dekoriert, zwischen Bauhaus und Art Nouveau, wird es Sie dazu verführen, das reiche und inspirierende Menü zu verkosten. Im Sommer kann man auf der Außenterrasse unter dem wachsamen Blick einer der größten Wächterstatuen des Musée de l'Homme einen noch atemberaubenderen Blick auf den Eiffelturm genießen.

Dans le cadre magique du Musée du même nom, le Café de l'Homme offre une vue imprenable sur la célèbre « dame de fer » de Paris. Un décor au design contemporain tout en intimité, oscillant entre Bauhaus et Art Nouveau, invite à la dégustation d'une carte riche et inspirée. En été, une vaste terrasse accentue la vue à couper le souffle sur la Tour Eiffel que surveille l'une des grandes statues gardiennes du Musée de l'Homme.

En el mágico marco del museo que le da nombre, el Café de l'Homme ofrece unas vistas inmejorables sobre la célebre "dama de hierro" de París. Decorado en un estilo contemporáneo e intimista que oscila entre la Bauhaus y el modernismo, todo en él invita a descubrir una carta extensa e inspirada. En verano, la amplia extensión de la terraza acentúa el impresionante espectáculo de la torre Eiffel frente a una de las grandes estatuas que guardan la entrada del Musée de l'Homme.

HIGHLIGHTS

COOL
PARIS

PARIS STREET ART

TAXI PARISIEN

METRO

L'AMOUR

BOIS DE BOULOGNE

Bois de Boulogne // Boulogne

Métro Porte d'Auteuil

With a surface area two and a half times bigger than Central Park, these former royal hunting grounds are like the lungs of Paris. All types of people can be seen here: young couples following the 17 miles of horse riding trails, families on the little train heading to the merry-go-rounds of the jardin d'acclimatation childrens' amusement park, set up under Napoleon III, or fishing enthusiasts casting their lines into each of the park's twelve artificial ponds, not far from the race course designed by the engineer Jean-Charles Alphand, in 1858.

Das einstige Jagdrevier der französischen Könige ist mehr als doppelt so groß wie der Central Park und gilt als grüne Lunge der Stadt. In dem Waldgebiet kommen alle auf ihre Kosten: Pferdebegeisterte freuen sich über das 28 km umfassende Netz an Reitwegen, junge Familien fahren mit einem Bähnchen zu den Karussellen im unter Napoleon III entstandenen Jardin d'Acclimatation, Angler können in den zwölf künstlichen Teichen auf Fischfang gehen. Ganz in der Nähe liegt auch die 1858 vom Ingenieur Jean-Charles Alphand angelegte Pferderennbahn.

D'une superficie 2,5 fois supérieure à Central Park, l'ancienne chasse royale est le poumon de Paris. On y croise tous les publics : de jeunes couples parcourent les 28 km de pistes équestres, les familles se dirigent en petit train vers les manèges du jardin d'acclimatation créé sous Napoléon III, et des pêcheurs essaient leurs lignes sur les douze étangs artificiels du bois, non loin de l'hippodrome conçu par l'ingénieur Jean-Charles Alphand en 1858.

Con una extensión dos veces y media superior a la de Central Park, los antiguos terrenos reales de caza son hoy el pulmón de París. Allí puede uno topar con gentes de todo tipo: parejas jóvenes que recorren sus 28 km de pistas ecuestres, familias que visitan los tiovivos del Jardín de Aclimatación creado durante el reinado de Napoleón III, pescadores que lanzan sus sedales a alguno de los doce estanques artificiales, todo a poca distancia del hipódromo diseñado en 1858 por el ingeniero Jean-Charles Alphand.

CIMETIÈRE DU PÈRE LACHAISE

16, rue du Repos // La Villette
Tel.: +33 (0I) 7I 28 50 82
www.pere-lachaise.com

November to March Mon–Fri 8 am to 5.30 pm
Sat 8.30 am to 5.30 pm
Sun & Holidays 9 am to 5.30 pm
March to November Mon–Fri 8 am to 6 pm
Sat 8.30 am to 6 pm
Sun & Holidays 9 am to 6 pm

Métro Père Lachaise

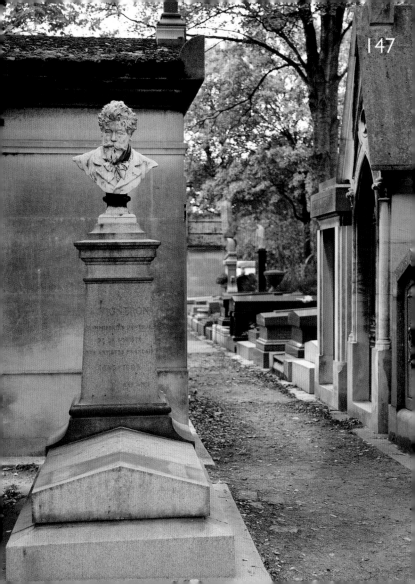

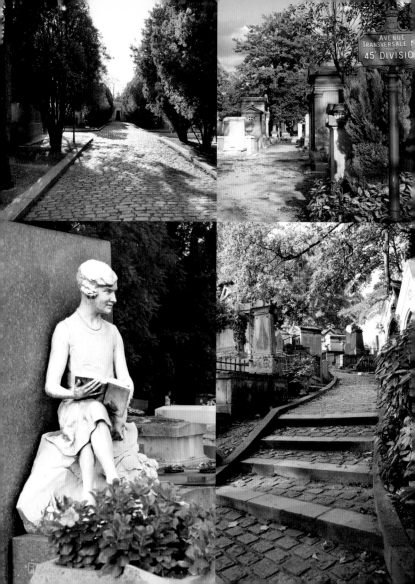

The largest cemetery in Paris was the final resting place of choice for numerous celebrities including Jim Morrison, Simone Signoret and Frédéric Chopin. It is a veritable museum, where renowned sculptors and architects have, over the past centuries, erected chapels, sculptures, mausoleums and crematoria of a neo-byzantine style. A visit to Père Lachaise seems therefore more like a walk through an abandoned, tree-lined sanctuary on the famous Parisian butte.

Viele bekannte Persönlichkeiten wie Jim Morrison, Simone Signoret oder Frédéric Chopin wählten den größten Pariser Friedhof als ihre letzte Ruhestätte. Im Laufe der Jahrhunderte schufen angesehene Bildhauer und Architekten Kapellen, Skulpturen, Mausoleen und neo-byzantinische Krematorien und ließen Père Lachaise zu einem wahren Museum werden. Der Besuch des inmitten von Bäumen auf der berühmten Pariser Anhöhe gelegenen Friedhofs gleicht einem Spaziergang durch ein verlassenes Refugium.

Le plus grand cimetière de Paris est la dernière demeure élue par nombre de personnalités, comme Jim Morrison, Simone Signoret ou Frédéric Chopin. Véritable musée, de prestigieux sculpteurs et architectes y ont élaboré chapelles, sculptures, mausolées et crématoriums néo-byzantins au fil des siècles. Ainsi, la visite du Père Lachaise prend l'apparence d'une promenade dans un sanctuaire abandonné au milieu des arbres de la célèbre butte parisienne.

El más famoso cementerio de París fue la última morada escogida por un gran número de celebridades, entre ellas Jim Morrison, Simone Signoret y Frédéric Chopin. Un verdadero museo en el que a lo largo de los siglos prestigiosos escultores y arquitectos han instalado capillas, esculturas, mausoleos y un crematorio neobizantino. De este modo, la visita al Père Lachaise se convierte en un paseo por un santuario abandonado entre los árboles de la celebre loma parisina.

PLACE DES VOSGES

Place des Vosges // Le Marais
www.parisinfo.com

Métro Saint-Paul

VOISIN
VOISINE } 12,€10

1 PLAT DU JOUR
+
1 VERRE DE VIN
ou
1 BIÈRE
+
1 CAFÉ

Aujourd'hui au Cafe Hugo

Salade Auvergnate

* Assiette du pecheur
Sauce crevettes
pièce maison

* Boeuf mode carottes

Crème caramel
maison

Accès Wi-Fi

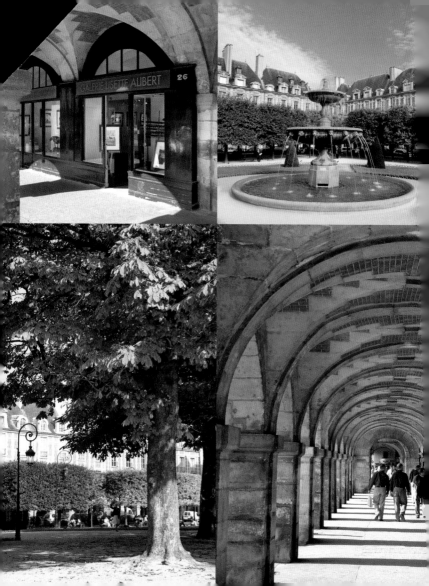

Inaugurated at the beginning of the 17ᵗʰ century, the oldest square in Paris is characterized by its sense of unity. Shaped in a near-perfect square, it is lined with red brick mansions and their grey slate roofs. Each one has its own story, which can be discovered as you stroll around this, the first constructed leisure area in France. In the summer, the square's 19ᵗʰ century trees will protect you from the sun, while in winter the arcades allow the drinking of tea to continue, out of the rain.

Der zu Beginn des 17. Jahrhunderts eingeweihte älteste Platz der Stadt Paris zeichnet sich durch seine Einheitlichkeit aus. Seine fast viereckige Fläche wird von Herrenhäusern aus rotem Backstein und grauen Schieferdächern gesäumt. Jedes der Häuser hat eine eigene Geschichte zu erzählen, die es bei einem Spaziergang auf Frankreichs erstem Erholungsgelände zu entdecken gilt. Im Sommer schützen die im 19. Jahrhundert gepflanzten Bäume vor der Sonne, im Winter laden die Arkaden zu einer Tasse Tee im Trockenen ein.

Inaugurée au début du XVIIᵉ siècle, la plus ancienne place de Paris marque par son unité. De forme presque carrée, elle est bordée de maisons de maître aux briques rouges et aux toits d'ardoises grises. Chacune a son histoire, à découvrir au fil des promenades dans le premier espace de détente de France. L'été, les arbres du square du XIXᵉ protègent du soleil ; l'hiver, les arcades permettent un thé à l'abri de la pluie.

Inaugurada a comienzos del siglo XVII, la plaza más antigua de París llama la atención por su uniformidad. De plano casi cuadrado, está delimitada por casas solariegas de ladrillo rojo y tejados de pizarra gris. Todas ellas tienen una historia propia que puede descubrirse a lo largo de un paseo por el primer espacio de recreo de Francia. En verano, los árboles de la plaza resguardan al viandante del sol; en invierno, es posible sentarse bajo las arcadas a beber té al abrigo de la lluvia.

MARCHES DU SACRÉ-COEUR

Parvis du Sacré-Cœur
Montmartre
www.parisinfo.com

Métro Anvers,
then Funiculaire de Montmartre

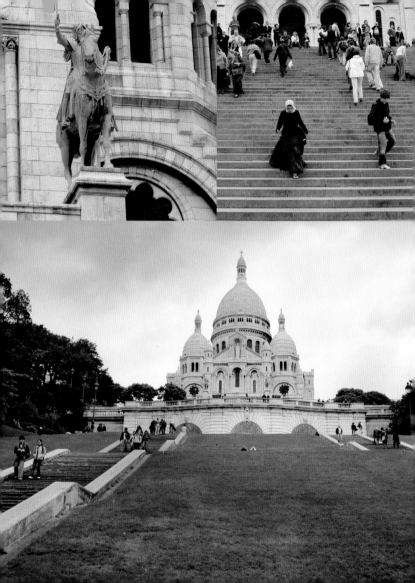

Since the construction of the Sacré-Cœur in 1875, its steps—the "escalier de la butte"—have played a vibrant role in Parisian daily life. Immortalised a hundred times by Robert Doisneau, they offer an unrivaled view of the city. The portrait painters are a fundamental part of the setting, just like the second-hand book dealers along the banks of the Seine. But these steps are more than a simple way of getting up to the famous romano-byzantine edifice: they form an integral part of its foundations.

Seit der Erbauung der Kirche Sacré-Cœur im Jahre 1875 sind die zu ihr hinaufführenden Treppen aus dem Pariser Alltag nicht mehr wegzudenken. Durch die zahlreichen Fotografien Robert Doisneaus unsterblich gemacht, bieten sie einen beeindruckenden Blick über die Stadt. Die Porträtisten gehören hier genauso hin wie die Bouquinisten ans Seine-Ufer. Die Stufen sind jedoch viel mehr als bloßer Zugang zu dem berühmten romanisch-byzantinischen Bauwerk: Sie sind fester Bestandteil des Fundaments.

Depuis la construction du Sacré-Cœur en 1875, les « escaliers de la butte » jouent un rôle vibrant dans le quotidien parisien. Cent fois immortalisés par Robert Doisneau, ils offrent une vue imprenable sur la ville. Les portraitistes font partie intégrante du décor, au même titre que les bouquinistes des quais de Seine. Mais ces marches sont plus qu'un simple moyen d'accéder au fameux édifice romano-byzantin : elles sont partie intégrante de ses fondations.

Desde la construcción del Sacré-Cœur en 1875, las "escaleras de la loma" desempeñan un vibrante papel en la vida cotidiana parisina. Cien veces inmortalizadas por Robert Doisneau, ofrecen unas vistas insuperables de la ciudad. Los retratistas forman parte integral del conjunto, al igual que los libreros de viejo en los muelles del Sena. Pero los peldaños mucho más que un simple modo de acceder al famoso edificio románico-bizantino: es también elemento clave de sus cimientos.

PARIS PLAGES

By the Seine River // Quais de Seine
www.parisinfo.com

mid July–end August 8 am to midnight

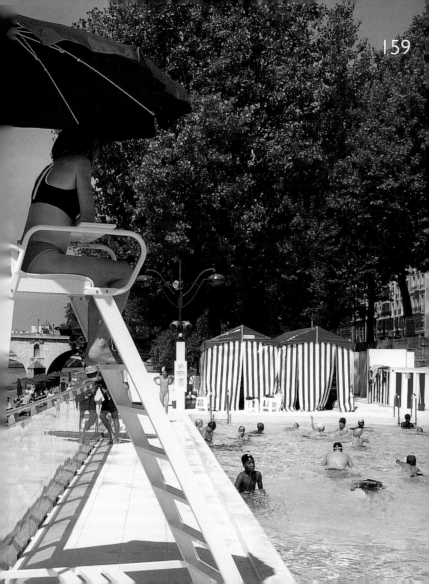

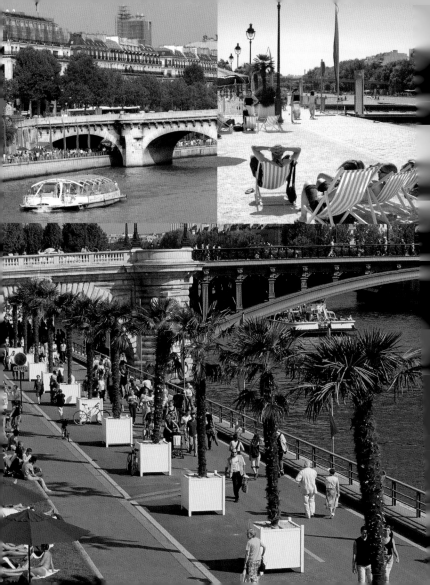

The Paris Mayor declared in 2002 that in summer, swimming costumes would be key. Parisian lovers of the summer months have since been able to enjoy sun bathing along the banks, bathing in the Seine not being allowed. Pavements of fine sand, palm trees, loungers and parasols redefine Voie Georges-Pompidou, as a beach. Between cafés, floating pools and beach volleyball it has never been so much fun to stay in Paris over the summer.

Seit 2002 heißt es für den Pariser jeden Sommer: Pack die Badehose aus! Wenn schon kein Bad in der Seine, so darf im Juli und August zumindest ein Sonnenbad am Seineufer genommen werden. Feiner Sand auf den Bürgersteigen, Palmen, Liegestühle und Sonnenschirme verwandeln die Voie Georges-Pompidou in ein wahres Strandparadies. Schwimmdocks, Lokale, Beach-Volleyball – nie war es für Pariser schöner, in der Ferienzeit in der eigenen Stadt zu bleiben.

La mairie de Paris l'a décrété en 2002 : l'été, le maillot de bain sera de mise. Juilletistes et aoûtiens parisiens peuvent depuis bénéficier d'un bain de soleil sur les quais – à défaut d'un bain de Seine. Trottoirs de sable fin, palmiers, transats et parasols redessinent la voie Georges-Pompidou pour lui donner des airs de plage. Entre guinguettes, bassins flottants et beach-volley, rester à Paris durant les congés n'a jamais été aussi gai.

En 2002, el ayuntamiento de París decidió que en verano, el traje de baño sería una opción muy a tener en cuenta. Desde entonces, y a falta de poderse bañaren el Sena, los parisienses pueden tomar el sol a orillas del río durante la canícula. Aceras de arena fina, palmeras, tumbonas y sombrillas afloran en la avenida Georges-Pompidou para darle un aire playero. Entre los merenderos, las piscinas flotantes y el voley-playa, París en época de vacaciones nunca fue tan divertido.

MUSÉUM D'HISTOIRES NATURELLES / JARDIN DES PLANTES

57, rue Cuvier // Quartier Latin
Tel.: +33 (01) 40 7 56 01
www.mnhn.fr

Daily 8 am to 5.30 pm

Métro / RER Gare d'Austerlitz

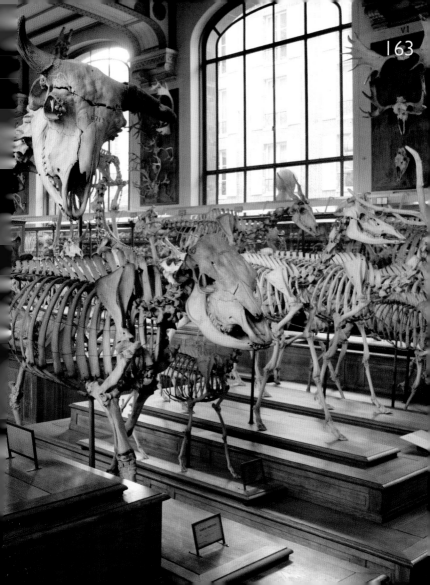

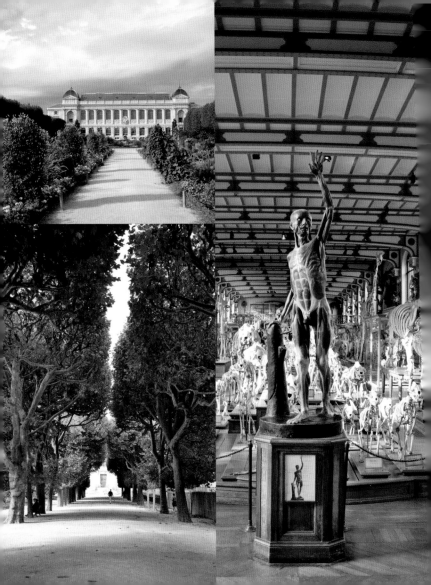

Neighbouring the Université de Jussieu, the garden of the Natural History Museum has something of a tree-lined university campus about it. It is within this idyllic setting that the 1,100 species of the menagerie can be existing seen side-by-side with students and visitors. Originally Louis XIII's medicinal plant garden, the park has been expanded and embellished by various different directors, as nominated by Kings of France. Perfumed avenues of lime trees, dating from 1740, remain as vestiges of that era.

Neben der Fakultät Jussieu gelegen, wirkt der botanische Garten des französischen Naturkundemuseums wie ein begrünter Universitätscampus. Studenten und Besucher teilen sich diesen idyllischen Ort mit den 1100 Tieren des dort ansässigen zoologischen Gartens. Einst Heilkräutergarten Ludwig des XIII, wurde der Park unter den von den französischen Königen ernannten Verwaltern vergrößert und verschönert. An diese Epoche erinnern die duftenden Lindenalleen, die 1740 gepflanzt wurden.

BRUNO FRISONI'S
SPECIAL TIP

Fabulous!
Magnificent!

Voisin de l'université de Jussieu, le jardin du Muséum d'Histoire Naturelle a des allures de campus universitaire verdoyant. Dans ce cadre idyllique, les 1100 animaux de la ménagerie coexistent avec les étudiants et visiteurs. A l'origine jardin de plantes médicinales de Louis XIII, le parc a été agrandi et embelli par les différents administrateurs nommés par les rois de France. Vestiges de cette époque : les allées parfumées de tilleuls, plantés en 1740.

Próximo a la universidad de Jussieu, el jardín del Museo de Historia Natural tiene el aire de un campus universitario selvático, en el que los 1100 ejemplares de la casa de fieras coexisten con estudiantes y visitantes. Concebido en sus orígenes como jardín de plantas medicinales de Luis XIII, los diferentes administradores nombrados por los reyes de Francia fueron ampliando y embelleciendo el parque. Vestigios de aquella época: las perfumadas avenidas de tilos, plantadas en 1740.

JARDIN DU LUXEMBOURG

Rue de Médicis, Rue de Vaugirard
Saint-Germain-des-Prés
www.parisinfo.com

Depending on Seasons, daily 7.15-8.15 am
to 2.45-9.30 pm

Métro Odéon
RER Luxembourg

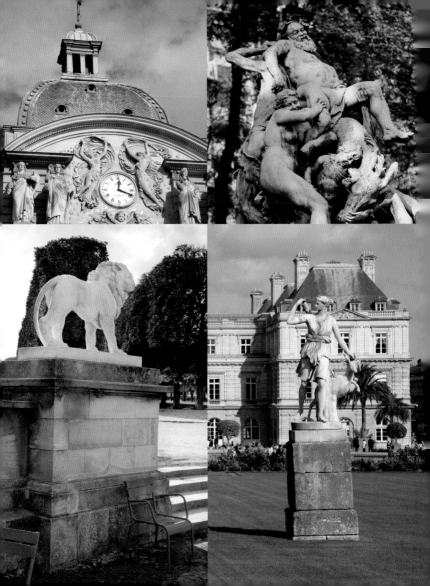

First open to the public under Napoleon, the Jardin du Luxembourg and its ornate, gold-plated central area welcome anyone from students to Parisians simply out for a stroll. With 57 acres at the centre of the Latin Quarter, the park can be the setting for all sorts of outings, whether wandering between the flower beds, sports lessons, beekeeping for beginners, visiting an exhibition in the shade of the Orangerie, or simply day dreaming on the Fermob chairs which were specially designed for the gardens.

Der unter Napoleon für die Öffentlichkeit zugänglich gemachte, von mit Blattgold verziertem Gitter umgebene Jardin du Luxembourg erfreut sich sowohl bei Pariser Studenten als auch Spaziergängern großer Beliebtheit. Der 23 Hektar umfassende Park liegt im Herzen des Quartier Latin und eignet sich für die unterschiedlichsten Freizeitaktivitäten: Flanieren zwischen den Blumenbeeten, Sport, Einführung in das Imkerhandwerk, Besuch einer Ausstellung im Schatten der Orangerie. Die von Fermob eigens für den Park entworfenen Stühle laden zum Tagträumen ein.

ELISABETH QUIN'S SPECIAL TIP

Le Luco Brasserie: the most family friendly, and intellectual friendly garden in Paris! Come here for the refreshments, the tennis, the palm trees, the picnics in Summer, the guignol and the famous spinach-green chairs.

Ouvert au public sous Napoléon, le Jardin du Luxembourg accueille dans l'enceinte de ses grilles dorées à la feuille d'or un public d'étudiants et de promeneurs parisiens. 23 hectares, situés au cœur du quartier Latin, permettent toutes les sorties : flânerie auprès des parterres de fleurs, cours de sport, initiation à l'apiculture, visites d'expositions à l'ombre de l'Orangerie, ou simples rêveries sur les chaises Fermob spécialement dessinées pour le jardin.

Inaugurado en tiempos napoleónicos, las rejas doradas del Jardin du Luxembourg acogen en su interior a un público formado por estudiantes y paseantes parisinos. Sus 23 hectáreas, ubicadas en el corazón del Barrio Latino, permiten actividades de todo tipo: deambular sin rumbo por entre los parterres, cursos deportivos, iniciación a la apicultura, exposiciones a la sombra de la Orangerie o simplemente sentarse a pensar en todo y en nada sobre las sillas Fermob especialmente diseñadas para el jardín.

PUCES DE SAINT-OUEN

140, rue des Rosiers
Saint-Ouen
Tel.: +33 (01) 40 12 32 58
www.parispuces.com

Sat–Mon 10 am to 5 pm

Métro Garibaldi or
Porte de Clignancourt

The wooden stands of Saint-Ouen boast an ever-growing collection of objets d'art, antiquities and vintage clothes. Since its beginning in the 19th century, this flea market has evolved to be organised and categorised in such a way that it has become the ideal Sunday outing, Paris style: a unique chance to haggle over a bronze Louis XIII with a cone of hot chestnuts in hand. Most of the 3,500 merchants are true connoisseurs who will guide newcomers through the labyrinth of this "courtyard of miracles".

Kunstgegenstände, Antiquitäten und Vintage-Klamotten geben sich in den Verkaufsbuden aus Holz ein buntes Stelldichein. Der Flohmarkt Saint-Ouen entstand im 19. Jahrhundert, entwickelte sich weiter, wurde organisiert und strukturiert und ist heute bei den Parisern als sonntägliches Ausflugsziel äußerst beliebt. Eine einzigartige Gelegenheit mit einer Tüte heißer Maronen in der Hand um eine Bronzefigur aus Zeiten Ludwig des XIII. zu feilschen. Die meisten der 3 500 Händler sind wahre Kenner, die den Laien gerne durch das Gewirr im „Cour de miracles" („Hof der Wunder") führen.

Sous les échoppes de bois de Saint-Ouen s'accumulent objets d'art, antiquités et fripes vintage. Depuis le XIX^e siècle, ces puces ont évoluées, se sont organisées et hiérarchisées afin de façon à devenir la sortie dominicale type des parisiens : l'occasion unique de marchander un bronze Louis XIII, un cornet de marrons chauds à la main. La plupart des quelques 3 500 vendeurs sont de vrais connaisseurs qui guideront le novice dans les dédales de cette « cour des miracles ».

Sobre los tenderetes de madera de Saint-Ouen se acumulan objetos de arte, antigüedades y ropa vintage. Los mercadillos han evolucionado desde el siglo XIX, y se han organizado jerárquicamente para convertirse en el destino ideal para las salidas dominicales de los parisinos, un lugar donde regatear por una estatuilla Luis XIII, con un cucurucho de castañas asadas en la mano. La mayoría de los casi 3 500 vendedores son verdaderos expertos y orientarán con gusto al neófito por esta "corte de los milagros".

PARC DU CHAMP DE MARS

Quai Branly,
Avenue de La Motte Picquet
Tour Eiffel
www.parisinfo.com

Métro Bir-Hakeim
RER Champ de Mars / Tour Eiffel

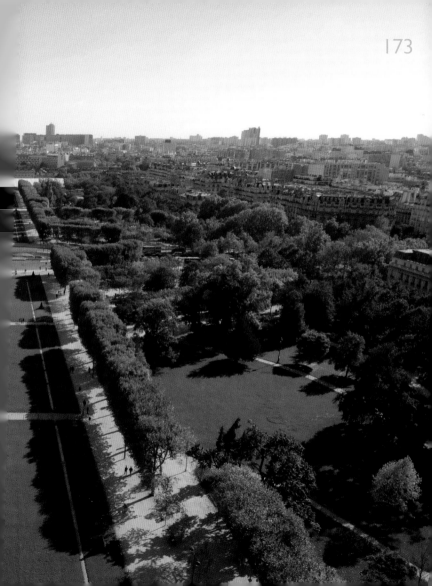

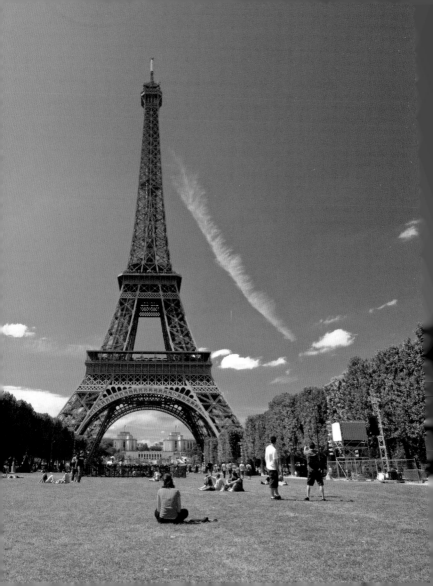

This living theatre of Parisian history has seen the blood of the Revolution flowing down its very alleys, and its flower beds covered by giant structures during the Universal Exhibition—this is a past that we can barely imagine today as we sit with friends around a picnic basket on the green lawns. The city also organises free exhibitions and concerts here. The sole witnesses to the history of the park remain the statues that punctuate the walkway from the military school to Trocadéro.

Auf dem Champ de Mars spielten sich wichtige Ereignisse der Pariser Geschichte ab. Das Blut der Revolution floss über seine Alleen, während der Weltausstellungen war der Rasen von riesigen Konstruktionen bedeckt. Beim Picknick mit Freunden lässt sich diese Vergangenheit heute allerdings nur schwer erahnen. Die Stadt organisiert auf dem Champ de Mars regelmäßig kostenlose Ausstellungen und Konzerte. Die einzigen Zeugen der vergangenen Zeiten sind die Statuen, die die Promenade von der École Militaire zum Trocadéro säumen.

Ce théâtre vivant de l'histoire parisienne a vu le sang de la Révolution couler sur ses allées et ses parterres se couvrir de structures géantes lors des expositions universelles, un passé que l'on devine à peine aujourd'hui, assis entre amis autour d'un pique-nique sur l'herbe verte. La ville y organise des expositions et des concerts gratuits. Seules témoins de l'histoire du lieu : les statues rythmant la promenade de l'école militaire au Trocadéro.

Escenario vivo de la historia parisina, su hierba y avenidas han visto correr la sangre de la Revolución y alzase gigantescas estructuras en las exposiciones universales, un pasado que apenas pueden adivinar hoy quienes acuden a los terrenos para disfrutar con sus amigos de un picnic al aire libre. La ciudad organiza aquí exposiciones y conciertos gratuitos. Testigos únicos de la historia del lugar: las estatuas que flanquean a intervalos regulares el paseo de la escuela militar del Trocadéro.

BASTILLE

There was a prison there where the Revolution started, now, you could find the Opera Bastille House, a modern building built to commemorate the Revolution's Bicentennial. Bastille is a historic area once specialized in furniture-making.

BOULOGNE

The Bois de Boulogne is a park located along the western edge of the 16th arr. It is full of activities on the weekends. Such as biking, jogging, boat rowing. During summer season the bois holds a 3-day weekend party in the month of July.

BOURSE

It is the "theatre district": a dozen or more can be found in this arrondissement. The Bourse area is also a great place to sample typical Parisian atmosphere: little passageways and arcades full of shops and small cafés.

BUTTES-CHAUMONT

The Buttes-Chaumont is not on the usual tourist circuit and is a great place to explore if you want to see where the locals go to get away from the grind. It is a sweeping romantic-style park whose dramatic bluffs, waterfalls, and rolling green hills provide a welcome sense of space and fresh air to overcrowded Parisians.

CHAMPS-ÉLYSÉES

The Champs-Élysées area is the most popular, the most frequented and the most chic area of Paris. It starts from the Triumphal Arch and goes along the Concorde Square where you could see the Grand Palais.

LE MARAIS

The oldest neighborhood in Paris. Many 18th century mansions that once housed the most noble families of Paris remain, such as the Hôtel de Rohan and historical museum the Carnavalet. Also known as the gay and trendy area.

LOUVRE

One of the main points of interest for tourists with the famous Louvre Museum, Place de la Concorde, Jardin des Tuileries and Place Vendôme all at once.

MONTMARTRE

The Montmartre hill is full of street artists (painters, sculptors and poets) who are essentially located on the Tertre Square. It is some kind of a village with its own pace of life, a very picturesque site.

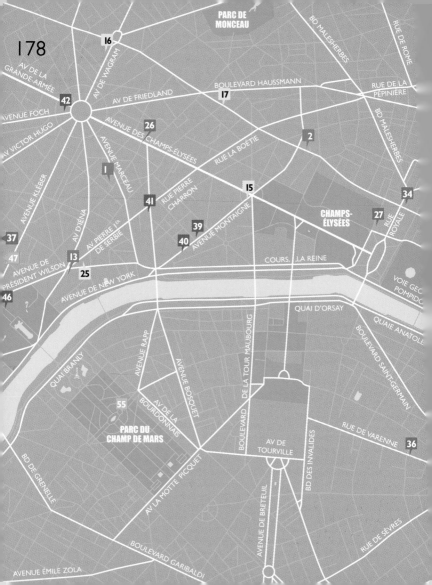

OPÉRA
The famous Opéra Garnier is located here and most of all, this district is renowned
for its department stores on Boulevard Haussmann: Printemps and the Galeries Lafayette.

PIGALLE
At the base of Montmartre stairs, famous for its nightlife: bars and clubs.
More likely the Red Light District of Paris and host neighborhood of the Moulin Rouge.

QUAIS DE SEINE
All sorts of books sold in a series of bottle-green boxes and their 240 book-sellers
line the banks of the Seine which turns into a beach resort in summer.

QUARTIER LATIN
The area around Saint-Michel and Latin Quarter is full of charm with its narrow pedestrianized
streets with cobblestones. It is also called the Little Athens because of its Greek inheritance.

RÉPUBLIQUE
The République area houses the most comprehensive contemporary art galleries in town,
so this quarter is full of them as well as museums. It is said to be the most magical area of
Paris—therefore a nice area to walk around.

SAINT-GERMAIN-DES-PRÉS
The former center of the existentialist movement stayed the ultimate hangout area for
bohemians and intellectuals. Trendy upscale boutiques, art galleries, and restaurants can
be found throughout this district.

SAINT-OUEN
Saint-Ouen is home to Paris's flea market, the most important concentration of antique
dealers and second-hand furniture dealers in the world. It is located in the northern suburbs.

TOUR EIFFEL
Famous yet quiet and typical Parisian neighborhood with its picturesque food market, its
cozy restaurants with a warm atmosphere, its colorful boutiques and typical café terraces.

TROCADÉRO
Site of the Palais Chaillot in the 16th arrondissement. The central terrace between its two
wings has been kept clear, forming a perfect frame for the Eiffel Tower beyond. The place
is also surrounded by chic restaurants and cafés.

COOL
CITY INFO

EMERGENCY

Ambulance	Tel.: 15
Police	Tel.: 17
Fire	Tel.: 18

ARRIVAL

BY PLANE
There are two international airports in the city area.
Information: www.aeroportsdeparis.fr

CHARLES DE GAULLE (CDG)
25 km / 15 miles north of downtown Paris. National and international flights.
With RER trains B from Terminal 1 and 2 via Gare du Nord to Châtelet / Les Halles station in the city center (30 mins). With Roissybus from Terminal 1, 2 and 3 to Opéra station (45–60 mins). With Air France coaches to Arc de Triomphe (40 mins) (www.carsairfrance.com).
A cab ride to downtown Paris costs approx. 50 euros (40 mins).

PARIS ORLY (ORY)
16 km / 10 miles south of the city center. National and international flights.
With RER line Orlyval to Antony station, then changing to RER line B to Châtelet / Les Halles station in the center (35 mins). With shuttle buses to RER station Pont de Rungis, then change to RER line C to Gare d'Austerlitz (35 mins). With Orlybus to RER station Denfert-Rochereau and then changing to RER line B to Châtelet / Les Halles in the city center (40 mins). With Air France coaches via Gare Montparnasse to the Invalides station (60 mins) (www.carsairfrance.com).
A cab ride to downtown Paris costs approx. 35 euros (30 mins).

BY TRAIN
There are six terminal stations in Paris: Gare Saint-Lazare, Gare du Nord, Gare de l'Est, Gare de Lyon, Gare d'Austerlitz and Gare Montparnasse, depending from which direction you are traveling from. All terminal stations have direct access to the Métro or the RER.
Further Railway Information SNCF:
Tel.: +33 8 36 35 35 35, www.sncf.fr
Thalys: www.thalys.com

TOURIST INFORMATION

OFFICE DU TOURISME DE PARIS
25, rue des Pyramides 75001 Paris
Tel.: +33 8 92 68 30 00
www.parisinfo.com
June–Oct opened daily from 9 am to 7 pm, Nov–May, Mon–Sat 10 am to 7 pm, Sun 11 am to 7 pm

Amongst others there are offices
at the Gare du Nord station, at
Carrousel du Louvre and at Place
du Tertre in Montmartre.

ACCOMMODATION

www.all-paris-apartments.com
Accommodations in Paris (EN)
www.parishotels.com
Hotel search engine and
online reservations (FR, EN)
www.paris-apts.com
Reservation of apartments (EN)
www.paris-sharing.com
Reservation of apartments (FR, EN)

TICKETS

Every Wednesday the event calendars
Pariscope and L'Officiel des Spectacles
with information on movies, theaters and
concerts as well as exhibition schedules
and opening hours are published.
TICKET OFFICES
FranceBillet:
Tel.: +33 8 92 69 21 92
www.otparis.francebillet.com
Fnac: www.fnac.fr
Check Théâtre: www.check-theatre.com.
Tickets for theater, opera, and concerts.
Kiosque Théâtre: 15, place de la Madeleine.
Discounted last minute theater tickets.

GETTING AROUND

PUBLIC TRANSPORTATION
www.ratp.fr RATP
Parisian Métro and RER

TAXI
Taxis Bleus, Tel.: +33 8 19 70 10 10
Taxis G7, Tel.: +33 1 47 39 47 39

VELIB' (BICYCLE SELF-SERVICE)
www.velib.paris.fr
20,600 bicycles over 1,450 stations
(1 every 300 meters) all around
the city. Free the first 30 mins then
1 to 4 euros for additional half hours.
Tel.: +33 1 30 79 79 30

CITY TOURS

SIGHTSEEING BUSES
Several agencies offer guided
city tours, thematic tours and
trips, lasting from 1.5 hrs up to
1 day, from 17.50 euros/pers.
There are open-topped double-
decker buses circulating in the
city center every 10–30 mins
with the possibility to interrupt
the tour at any tourist attraction,
day ticket 25 euros/pers.,
2-day ticket 28 euros/pers.
Cityrama, 149, rue Saint-Honoré
Tel.: +33 1 44 55 61 00
www.cityrama.com

COOL
CITY INFO

Les Cars Rouges, 17, quai de Grenelle
Tel.: +33 1 53 95 39 53
www.carsrouges.com
Paris l'OpenTour, 13, rue Auber
Tel.: +33 1 42 66 56 56
www.paris-opentour.com
Paris Vision, 214, rue de Rivoli
Tel.: +33 1 42 60 30 01
www.parisvision.com

BICYCLES TOURS
Guided half and full day bicycle
tours as well as tours in the
evening are organized regularly by:
Paris à Vélo c'est sympa
22, rue Alphonse-Baudin
Tel.: +33 1 48 87 60 01
www.parisvelosympa.com
Paris-Vélo, 2, rue du Fer à Moulin
Tel.: +33 1 43 37 59 22
www.paris-velo-rent-a-bike.fr

BOAT TOURS
Seine Tours
Bateaux Parisiens
Tel.: +33 8 25 01 01 01
www.bateauxparisiens.com
Compagnie des Bateaux Mouches
Tel.: +33 1 42 25 96 10
www.bateauxmouches.com
Vedettes de Paris
Tel.: +33 1 44 18 19 50
www.vedettesdeparis.com
Batobus, www.batobus.com

CHANNEL TOURS
Canauxrama
Tel.: +33 1 42 39 15 00
www.canauxrama.com
Paris Canal
Tel.: +33 1 42 40 96 97
www.pariscanal.com

GUIDED TOURS
Paris Balades
www.parisbalades.com
Tours through Paris with certified
tourist guides. The website gives an
overview of the program and the
organizing companies.

ART & CULTURE
www.journee-du-patrimoine-paris.fr
Journées du Patrimoine mid Sept,
open day in historical and public buildings
www.legeniedelabastille.net
Artists and galleries in the
Bastille district (FR)
www.monum.fr
Presentation of national architectural
monuments, e. g. Notre-Dame,
Arc de Triomphe, Sainte-Chapelle,
Panthéon (FR, EN)
www.parisbalades.com
Virtual walk through Paris with
detailed information on the districts
and architectural monuments (FR)

COOL
CITY INFO

www.paris-pittoresque.com
The historical Paris with ancient
pictures and engravings (FR)
www.picturalissime.com
Overview over Parisian museums
with links (FR, EN)
www.theatreonline.com
Theater guide (FR)

SPORTS AND LEISURE

www.bercy.fr
Sports calendar and
opening hours of the ice rink in
the Palais Omnisports Paris-Bercy (FR)
www.boisdevincennes.com
Leisure activities in the large Bois
de Vincennes park (FR)
www.disneylandparis.com
Website of the famous
amusement park (EN)
www.pari-roller.com
Exploring Paris on inline skates,
every Fri night for advanced
skaters, every Sun afternoon for
beginners (FR, EN)

GOING OUT

www.parissi.com
Concerts, exhibitions,
restaurants, bars and clubs (FR)
www.parisvoice.com
Scene guide with tips from
the editorial staff and calendar
of events (EN)

EVENTS

Fête de la Musique
21st June, Open air concerts of
diverse genres (classical music, jazz
and rock, world music, etc.) in the
parks, squares and streets
www.fetedelamusique.culture.fr

Banlieues Bleues
At the beginning of March until the
beginning of April, Jazz and world
music festival in the northeastern suburbs
www.banlieuesbleues.org

Fête Nationale
14th July, the evening before the national
holiday there are public balls, processions
and fireworks, on the 14th there is a huge
military parade on the Champs-Élysées
www.14-juillet.cityvox.com

Festival d'Automne
Mid Sept–mid Dec, music, theater,
and movie festival on several Parisian stages
www.festival-automne.com

Nuit Blanche
At the beginning of Oct,
a night full of cultural events

COOL
CREDITS

COVER by Martin/Le Figaro Magazine/Laif
Illustrations by Sonja Oehmke

p 2–3 (Place de la Concorde)
by Matthias Just (further credited as mj)
p 6–7 (Paris) by Martin Nicholas Kunz
(further credited as mnk)
p 8–9 (Tour Eiffel) by mnk

HOTELS

p 14–15 (Hôtel Keppler) by Fabrice Rambert;
p 16–19 (Hôtel Le Bristol Paris) p 17 by Gerard
Uferas, p 17 and 18 right bottom by Sordello, p 18
top (2) by Romeo Balancourt, p 18 left bottom by
Reto Guntli, all images courtesy of Le Bristol; p 20
(Little Palace Hotel) top (2) by Roland Bauer (further
credited as rb) and bottom (2) by Christophe Bielsa;
p 22 (Hôtel Lumen Paris) all photos courtesy of Hôtel
Lumen; p 24 (Hôtel Amour) all photos courtesy
of Hôtel Amour; p 26–29 (Mama Shelter) all pho-
tos by DR/courtesy of Mama Shelter; p 30 (Hôtel
Le Petit Paris) all photos by Christoph Bielsa; p 32
(Hôtel Gabriel Paris Marais) all photos by Christophe
Bielsa; p 34–37 (Murano Resort) all photos by rb;
p 38 (Apostrophe Hôtel) all photos by Edo Berto-
na; p 40 (Hôtel Bel Ami) all photos by Patricia Pari-
nejad; p 42–45 (L'Hôtel) all photos by Anne-Laure
Jacquard; p 46–49 (Shangri-La Hotel Paris) all photos
by Markus Gortz

RESTAURANTS +CAFÉS

p 52 (Le Moderne) all photos by Joerg Lehmann;
p 54 (Café Artcurial) all photos courtesy of Café
Artcurial; p 56 (Makassar Lounge & Restaurant) all
photos courtesy of Makassar; p 58 (Oth Sombath)
all photos courtesy of Oth Sombath; p 60 (Le Der-
rière) all photos courtesy of Le Derrière; p 62 (La
Gioia) all photos courtesy of VIP Room; p 64 (Le Saut
Du Loup) all photos courtesy of Le Saut Du Loup;
p 66 (Yachts de Paris - Don Juan II) photo courtesy of
Yachts de Paris; p 68 (La Fidélité) all photos courtesy
of La Fidélité; p 70 (Café de Flore) all photos by rb;
p 72 (Les Cinoches) all photos by Justin Winz (further
credited as jw); p 74 (Tokyo Eat) all photos courtesy
of Palais de Tokyo

SHOPS

p 78 (Louis Vuitton) left top and right by Stephanie
Muratet, left bottom by Jimmy Cohrssen/all courtesy
of Louis Vuitton; p 80 (L'Éclaireur) all photos cour-
tesy of L'Éclaireur; p 82–85 (Kiliwatch) all photos by
jw; p 87–89 (Galeries Lafayette) all photos by mj;
p 90 (Bubblewood) all photos courtesy of Bubble-
wood; p 92 (Mariage Frères) all photos courtesy of
Mariage Frères; p 94 (Boutique Chantal Thomass) all
photos courtesy of Chantal Thomass; p 96 (Colette)
all photos courtesy of Colette; p 98 (Ladurée) all
photos by jw; p 100 (Jeanne A) all photos by Joerg
Lehmann; p 102 (La Pâtisserie des Rêves) all photos
courtesy of La Pâtisserie des Rêves; p 104 (Bathroom
Graffiti) all photos courtesy of Bathroom Graffiti

CLUBS, LOUNGES +BARS

p 108–110 (Barrio Latino) all photos by jw; p 112
(Bar du Plaza) all photos courtesy of Plaza Athenée;
p 114–117 (La Maison Blanche) all photos courtesy of
La Maison Blanche; p 120–121 (Blitz Tequila Bar) all
photos by jw; p 122–125 (L'Arc) all photos by Jean-
Pierre Salle; p 126 (Le Renard) all photos courtesy of
Franklin Azzi Architecture; p 128–131 (VIP Room) all
photos courtesy of VIP Room; p 132–135 (Chez Mou-
ne) all photos by jw; p 136–139 (Café de l'Homme)
all photos by rb

HIGHLIGHTS

p 142–145 (Bois de Boulogne) all photos by mj; p 146–
149 (Cimetière du Père Lachaise) all photos by mj;
p 150–153 (Place des Vosges) p 152 left top by 2011
iStockphoto, all other by mj; p 154–157 (Marches
du Sacré-Coeur) all photos by mj; p 158–161 (Paris
Plages) p 158–159 by Sophie Robichon, p 160 left
top by David Lefranc, right top by Marc Bertrand,
bottom by Raymond Sahuquet/all photos courtesy of
Paris Tourist Office; p 162–165 (Muséum d'Histoires
Naturelles / Jardin des Plantes) all photos by mj;
p 166–169 (Jardin du Luxembourg) all photos by mj;
p 170 (Puces de Saint-Ouen) photo by Paris-Sharing.com;
p 172–175 (Parc du Champ de Mars) all photos by
2011 iStockphoto; p 191 (Tour Eiffel) by mj

COOL CITIES

Pocket-size Book,
App for iPhone/iPad/iPod Touch
www.cool-cities.com

A NEW GENERATION

of multimedia lifestyle travel guides
featuring the hippest most fashionable
hotels, shops, and dining spots for
cosmopolitan travelers.

VISUAL

Discover the city with tons
of brilliant photos and videos.

APP FEATURES

Search by categories, districts, or geo locator;
get directions or create your own tour.

COOL
BERLIN

With special tips
from Tita von Hardenberg

A new visual guide to the coolest hotels, restaurants,
cafes, clubs, bars, lounges, shops, highlights and more

teNeues

ISBN 978-3-8327-9486-6

BRUSSELS
VENICE
BANGKOK
MALLORCA+IBIZA
NEW YORK
AMSTERDAM
MIAMI
MEXICO CITY
HAMBURG
LONDON
ROME
MILAN
BERLIN
FRANKFURT
STOCKHOLM
BARCELONA
COPENHAGEN
LOS ANGELES
SHANGHAI
TOKYO
SINGAPORE
VIENNA
BEIJING
COLOGNE
PARIS
HONG KONG
MUNICH

ART
ARCHITECTURE
DESIGN

Pocket-size Book,
App for iPhone/iPad/iPod Touch
www.aadguide.com

A NEW GENERATION

of multimedia travel guides featuring
the ultimate selection of architectural
icons, galleries, museums, stylish
hotels, and shops for cultural and
art conscious travelers.

VISUAL

Immerse yourself into inspiring
locations with photos and videos.

APP FEATURES

Search by categories, districts, or
geo locator; get directions or create
your own tour.

ISBN 978-3-8327-9435-4

BARCELONA
SHANGHAI
TOKYO
SINGAPORE
BEIJING
VIENNA
PARIS
SYDNEY
HONG KONG
MUNICH
ZURICH
NEW YORK
SAO PAULO
AMSTERDAM
MIAMI
MEXICO CITY
HAMBURG
LONDON
ROME
EMIRATES
CHICAGO
MILAN
BERLIN

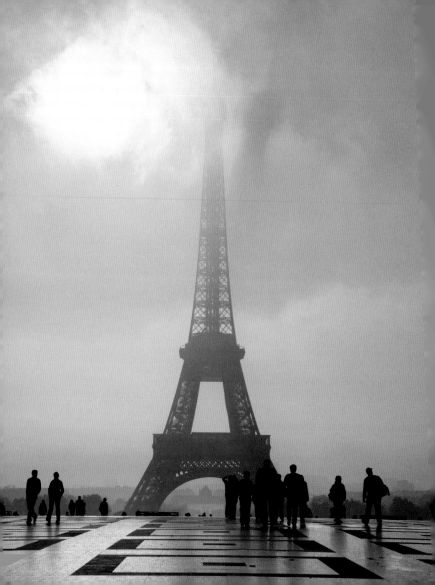

© 2011 Idea & concept by Martin Nicholas Kunz, Lizzy Courage Berlin
Selected and edited by Nathalie Grolimund
Introduction, backcover and location texts by Camille Scelles
Executive Photo Editor: David Burghardt, Photo Editor: Maren Haupt
Copy Editor: Dr. Simone Bischoff
Art Director: Lizzy Courage Berlin, Design Assistant: Sonja Oehmke
Imaging and pre-press production: Andreas Doria, Hamburg
Translations: Übersetzungsbüro RR Communications Romina Russo,
Lisa Caprano, Romina Russo (German), Zoe Cecilia Brasier, Romina Russo (English),
Pablo Álvarez, Romina Russo (Spanish)

© 2011 teNeues Verlag GmbH + Co. KG, Kempen

teNeues Verlag GmbH + Co. KG
Am Selder 37, 47906 Kempen // Germany
Phone: +49 (0)2152 916-0, Fax: +49 (0)2152 916-111
e-mail: books@teneues.de

Press department: Andrea Rehn
Phone: +49 (0)2152 916-202 // e-mail: arehn@teneues.de

teNeues Digital Media GmbH
Kohlfurter Straße 41–43, 10999 Berlin // Germany
Phone: +49 (0)30 700 77 65-0

teNeues Publishing Company
7 West 18th Street, New York, NY 10011 // USA
Phone: +1 212 627 9090, Fax: +1 212 627 9511

teNeues Publishing UK Ltd.
21 Marlowe Court, Lymer Avenue, London SE19 1LP // UK
Phone: +44 (0)20 8670 7522, Fax: +44 (0)20 8670 7523

teNeues France S.A.R.L.
39, rue des Billets, 18250 Henrichemont // France
Phone: +33 (0)2 4826 9348, Fax: +33 (0)1 7072 3482

www.teneues.com

Bibliographic information published by the Deutsche Nationalbibliothek.
The Deutsche Nationalbibliothek lists this publication in the
Deutsche Nationalbibliografie; detailed bibliographic data are
available in the Internet at http://dnb.d-nb.de.

Printed in the Czech Republic
ISBN: 978-3-8327-9489-7

MIX
Papier aus verantwortungsvollen Quellen
Paper from responsible sources
FSC® C005833